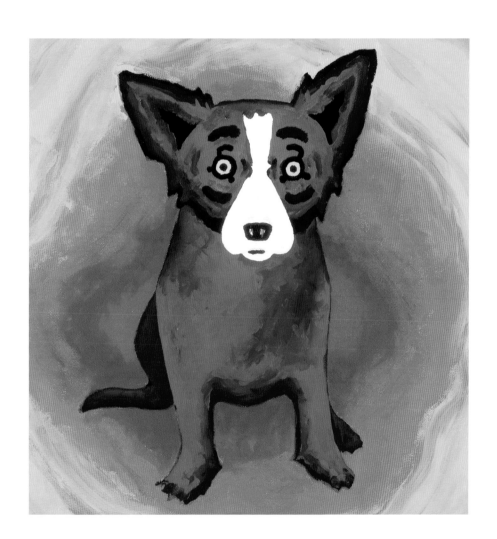

GEORGE AND WENDY RODRIGUE

BLUE DOG

Edited by David McAninch

Designed by
Alexander Isley Inc.

Stewart, Tabori & Chang
New York

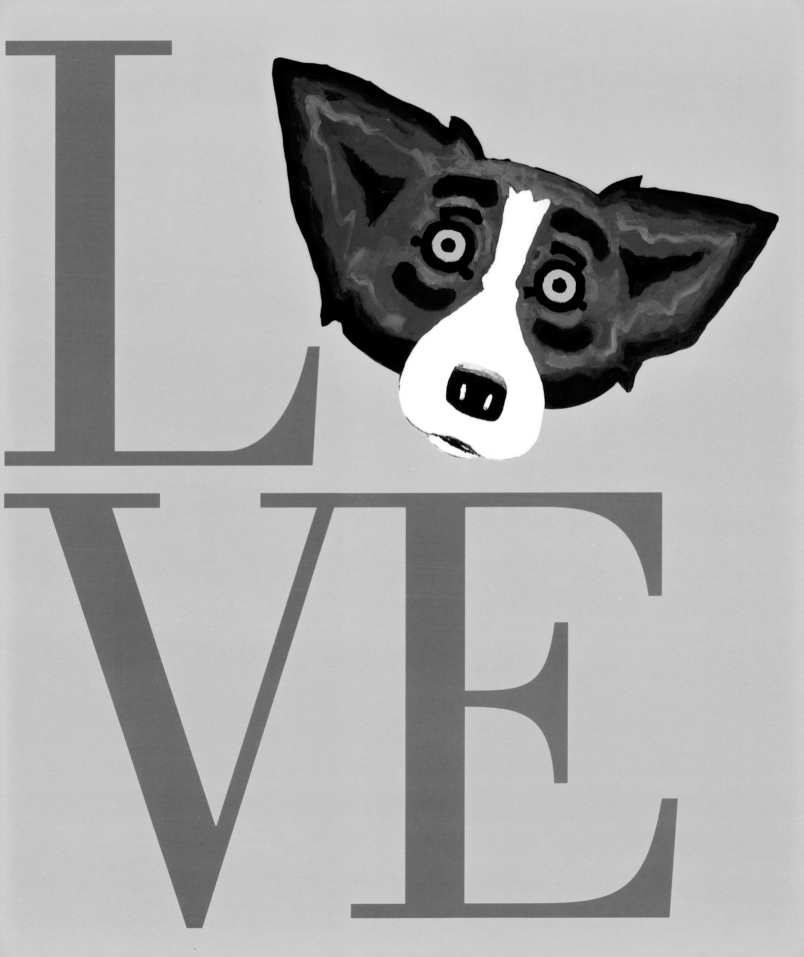

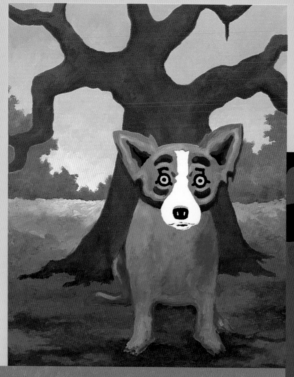

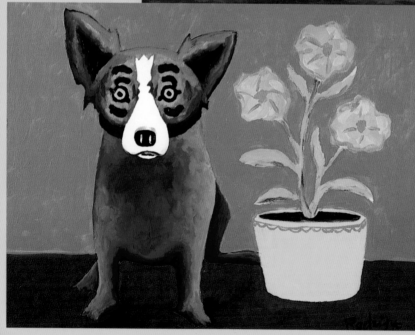

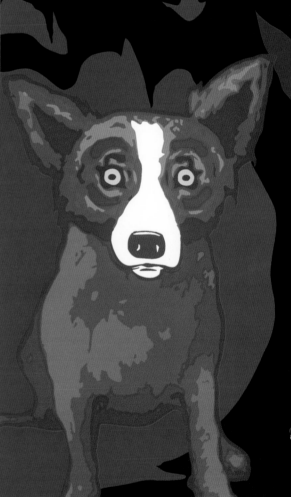

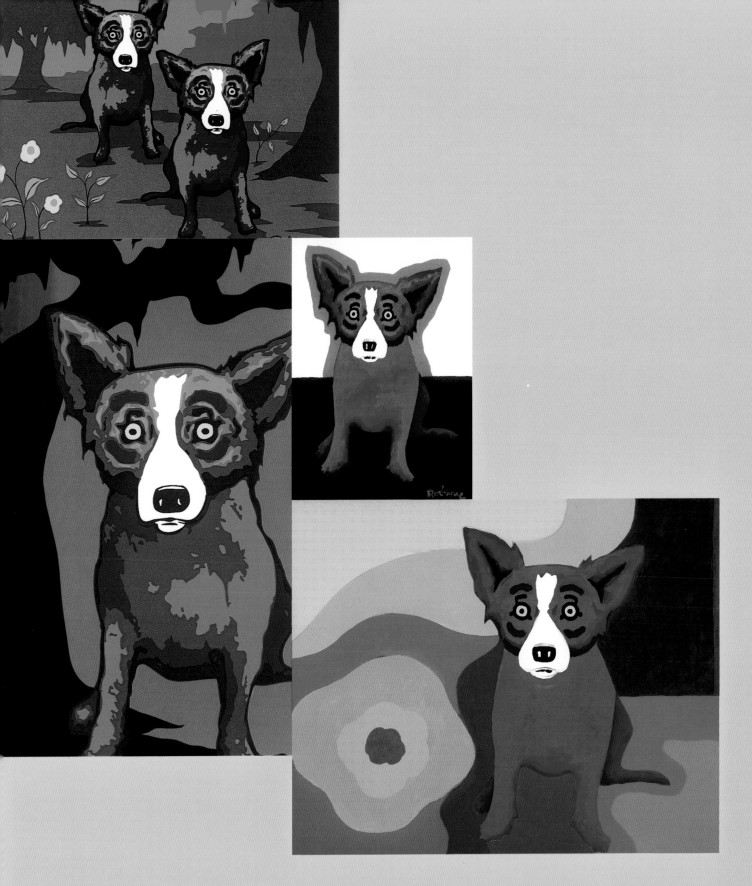

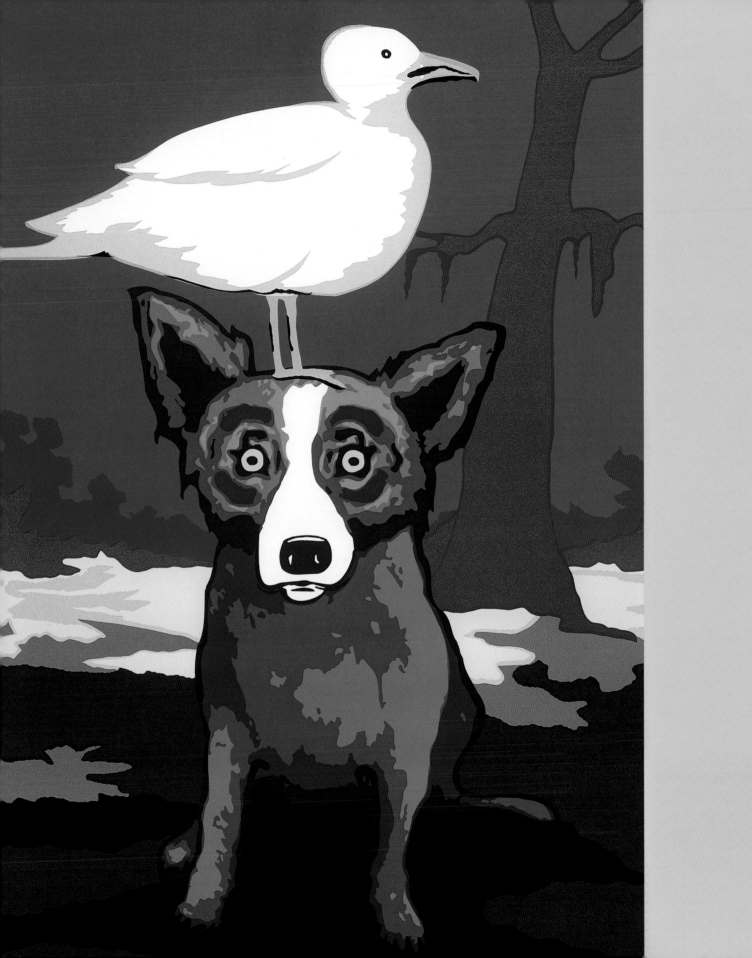

Introduction

10

Chapter One

Out of the Blue

22

Chapter Two

Big Trouble

38

Chapter Three

Looks Like Love Came over Me

64

Chapter Four

Just in Time

82

Epilogue

102

Introduction

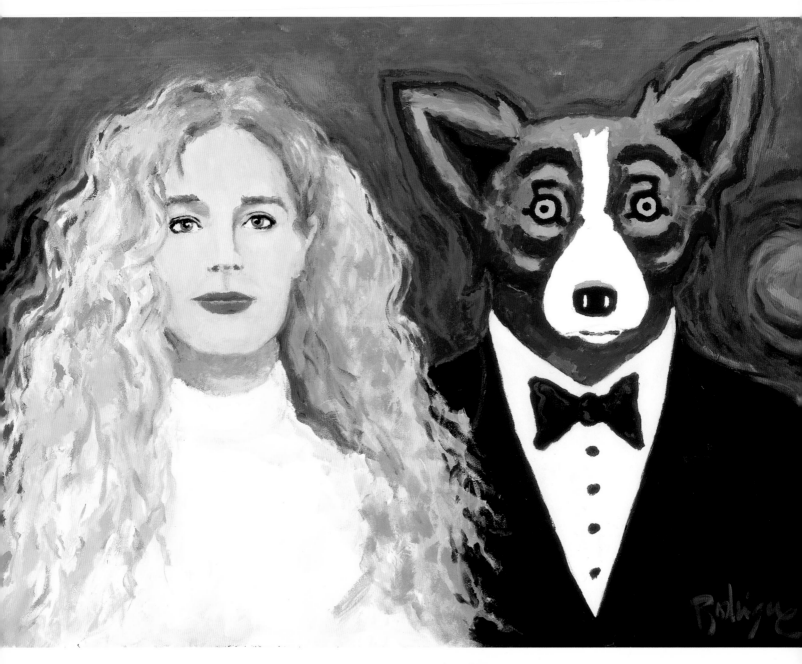

Wendy and Me

Back in 1974 I painted a portrait called *Jolie Blonde*, based on the sad Cajun waltz of the same name. At the time I didn't know that I was waiting for my own *Jolie Blonde*—that twenty years later my life would begin anew. I can never really know unhappiness again, because my *Jolie Blonde* came back to me after all those years. This painting was our wedding portrait.

It's easy to assume that I love the Blue Dog paintings because I love the man who created them. But when I first set foot in the Rodrigue Gallery on Royal Street in New Orleans more than a decade ago, I had never met George Rodrigue. When I beheld a Blue Dog painting, my inner skeptic noted: It's just a dog. It didn't make sense for me to like these paintings. I certainly wasn't what you'd call a "dog person," and my artistic tastes leaned more toward Northern Renaissance religious scenes than to color-saturated Pop Art. So why was I suddenly taken with these paintings? Why was anyone, for that matter? People said that the dog looked sad or lost or scary or funny. There were as many opinions about the appeal of the Blue Dog paintings as there were people to offer them.

Yet I couldn't deny the fact that I was suddenly crazy about these images. The more time I spent around George's work, the more my enthusiasm grew. Once I started working in the gallery, I discussed the paintings every day with strangers who walked in. I never had a

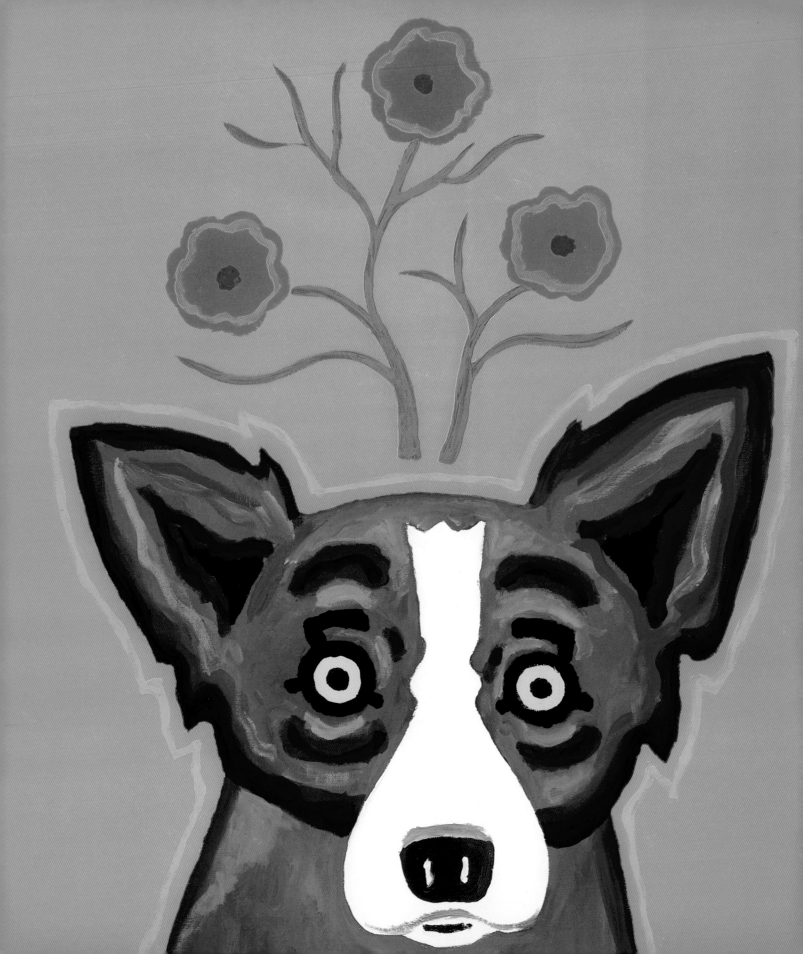

prepared response: With some people I emphasized the unique graphic elements and color schemes of George's work, with others the Cajun werewolf legend of the *loup-garou*, and with still others the story of George's deceased studio dog, Tiffany. After a while the only thing that seemed certain was that each Blue Dog painting was whatever the beholder wanted it to be. Indeed, the reason I never felt compelled to "get my story straight" about the Blue Dog was that the dog itself isn't a character in a narrative or a cartoon, or even a fixed symbol of any one thing—it is nothing more and nothing less than a reflection of all the truths, joys, sorrows, dreams, and loves of its creator.

Now that I am a part of George's life and he is a part of mine, I often see myself reflected in these Blue Dog paintings—sometimes literally, sometimes more subtly. And George endows every single Blue Dog painting, from his early bayou landscapes to his exuberant latter-day canvases, with the most pure and genuine love. Love for

15

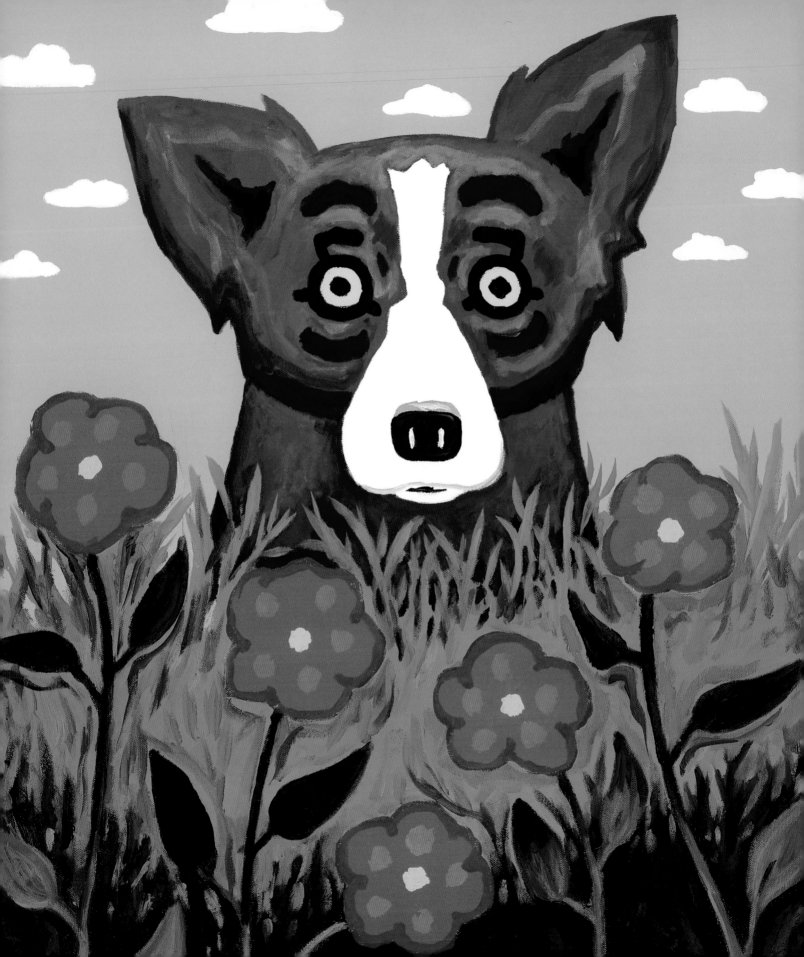

Peep-Eye in the Poppies
**My daddy died in 1967. When I
was a baby, he played peep-eye
with me as we lay in the front
yard looking at the clouds.**

me, for his family, for life, and for the gift of art itself.
Being with George has turned my ideas about art upside
down; now I see truth and sincerity of expression where I
never could see them before. And in a world full of critics
and givers of questionable advice (his own mother once
told him, "You'll never make any money painting that
dog"), George is the only expert on his art that I know.
I have the great honor of being his partner in life, and I
believe George would have found success with or without
me. As for his occasional suggestion that he needs me in
order to make it all happen, it's a delirium I chalk up to love.

–Wendy Rodrigue

My artwork and my career have always been very personal and self-contained. I consulted no one about my business. I took no advice about my painting. I did things most people thought I shouldn't or couldn't do. And despite the fact that I always seemed to be surrounded by other people's opinions, I still lived my life with utter independence.

Then out of nowhere, I met someone who shares my love for art and who lives with the same independence as me. We both knew from the beginning that we were very much alike. I could draw and create, and she would understand where I was going before my thoughts were concrete. That had never happened to me before. Her opinions mirrored my own thinking. There was no energy lost on explaining something, because by the time I tried to put my feelings into words, she already knew what I was going to say. When I share my ideas with her, they have increased potential to take shape and expand because she never inhibits me.

In so many of my paintings, I have tried to show that different shapes and colors can harmoniously combine to form a visual statement more powerful and more joyful than the sum of its parts. Even though I paint my ideas with my own two hands, the center of my life—the love in my life—is always in the background supporting me.

–George Rodrigue

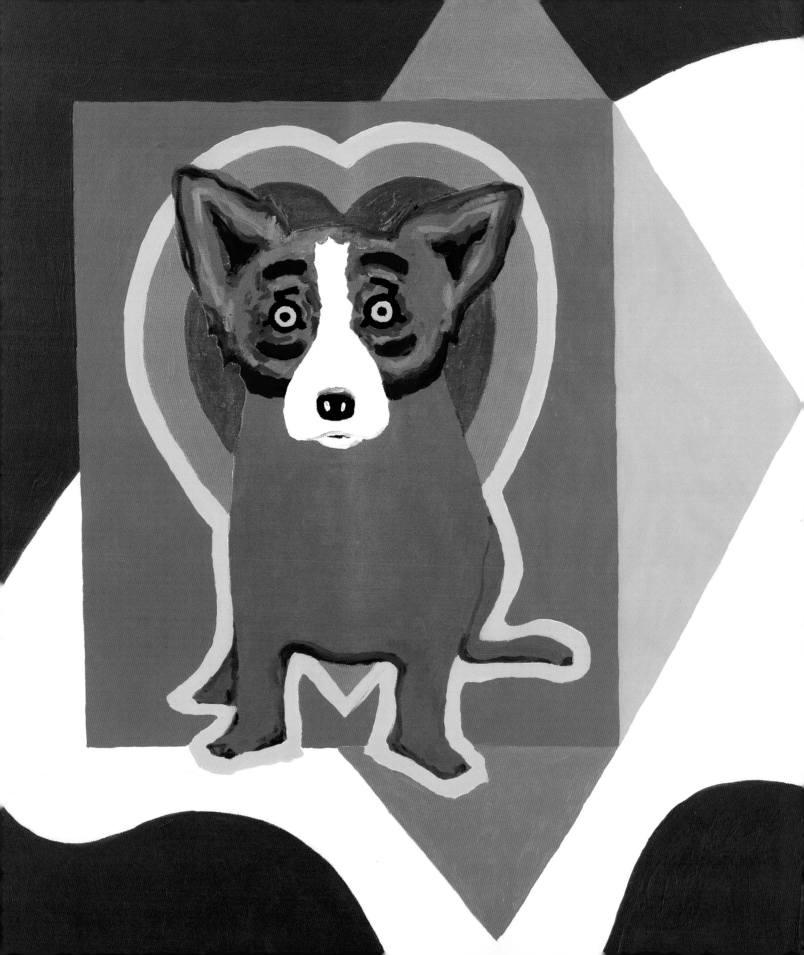

It's a Wild, Wild Life
When we met, Wendy and I were outwardly very different.
I grew up in the fifties; she grew up in the seventies. My family
is Cajun; hers is Southern. It was art and especially the Blue Dog
that opened the door to all our similarities.

Chapter One

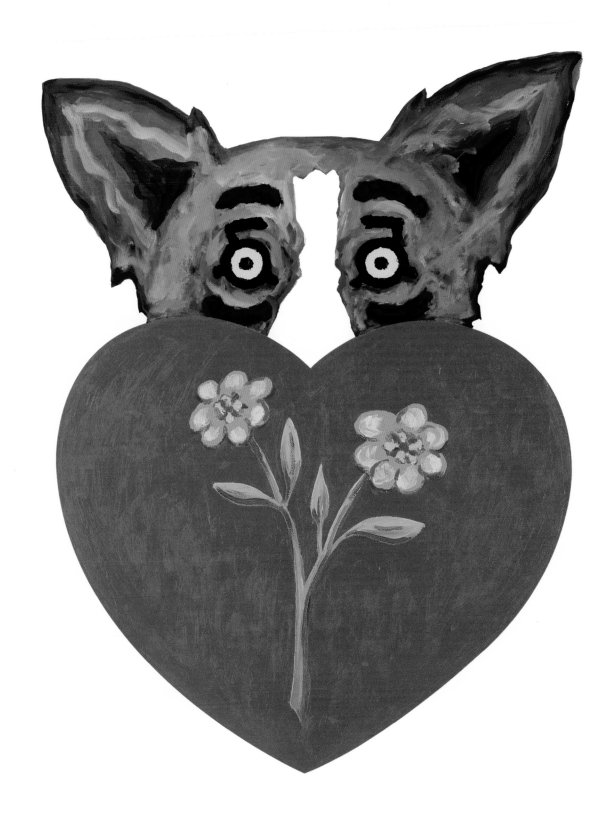

I didn't plan the Blue Dog series. It happened without my knowing it. I created these paintings because I liked them, and then they were famous. The fact that they evolved into my main subject matter was a result of perfect timing. Had I painted them as a young man, I might have traded their inspirational value for a monetary one. Instead, the series appeared out of the blue at a time when I had the confidence to incorporate it as an element of style—using it as the basis for new designs and feelings on canvas.

True love was as unexpected as the Blue Dog. We all know that if we look for something, we never find it. But if it finds us, we immediately know when it feels right. For forty years I painted for the love of it. But when I met someone who understood me and what I do, I found that my passion for painting became a passion for sharing. Again the timing was perfect. They say that love puts a new spring in your step: A person walks differently after they've found love. In the same way, love is the most recent addition to my style. To my mind, I am not out there painting on my own anymore, trying to make people understand my vision. There is more feeling in my canvases today than ever before, and there is at least one person who understands that as well as I do.

—GR

OUT OF THE BLUE

"And think not you can direct the course of love, for love, if it finds you worthy, directs your course."
–Kahlil Gibran

THE DAY I SAW MY FIRST BLUE DOG I WAS LOST. WHAT I MEAN IS, I KNEW PERFECTLY WELL THAT I WAS STANDING IN FRONT OF THE THE RODRIGUE GALLERY ON ROYAL STREET IN NEW ORLEANS, but I was very much in need of some direction. I was on this particular corner because I had decided to seek the advice of a friend who worked at the gallery. I was a twenty-three-year old graduate student in art history at Tulane University and I needed a job. More than that, I needed a sense of purpose. Yes, I wanted a paycheck, but I also wanted to feel like I was a part of something inspiring. So I had decided to hit my friend up for advice on how to get a leg up in the art business.

The moment I crossed the threshold into the gallery, however, my thoughts froze. I was transfixed—not by the scores of paintings stacked salon-style throughout the gallery, but rather by a single heart-stopping canvas hanging on the far wall of the room. I beheld a thickly painted composition of green, yellow, and blue, and I remember

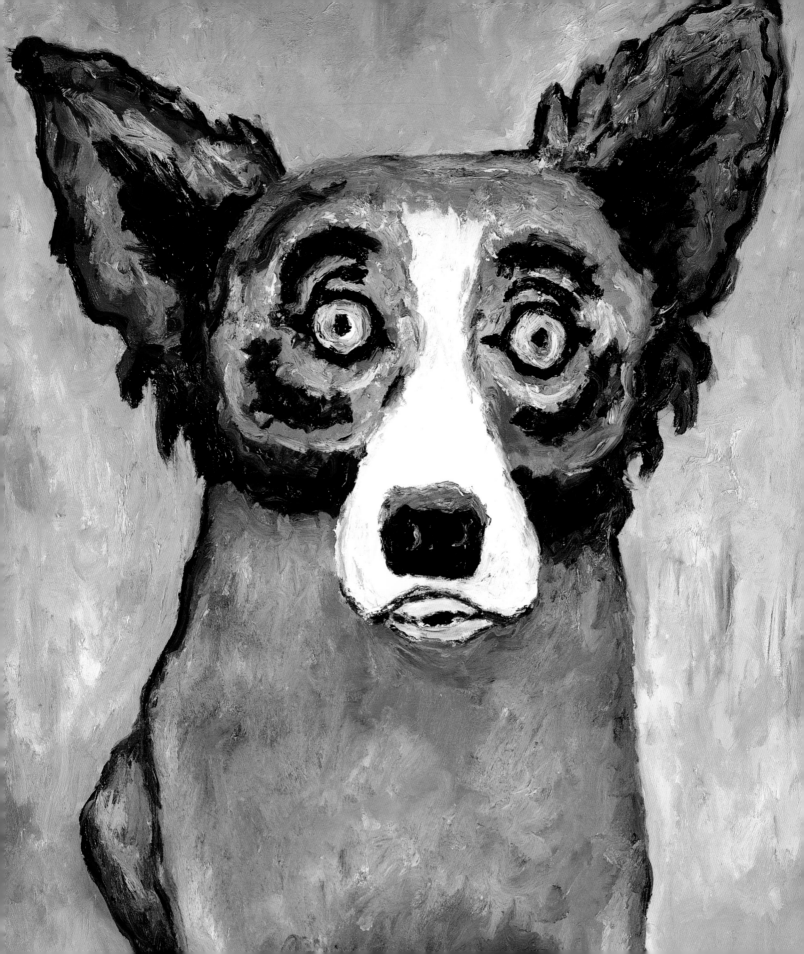

my lips parting in a whisper . . . "What IS this?"
I tried to get my bearings, but this painting would simply not let me *not* look at it. I really didn't know much about contemporary art. I had seen the Warhols, Pollocks, and Closes in books, but I had spent most of my time studying Northern Renaissance painting and the art of ancient Greece and Egypt. Yet there I was, mesmerized by this bold, surreal icon. I recognized that it had the shape and basic features of a dog, but that fact came to me only as an afterthought.

It wouldn't be the last I'd see of that particular painting, nor would it be the last time I'd be struck speechless by this unusual painted figure. As my friend showed me around, I encountered more Blue Dog canvases, scattered among the more somber Cajun portraits and landscapes on which George Rodrigue had launched his career. Like almost anyone who had lived in New Orleans for a while, I had heard of George and had walked by his gallery many times. I had seen some of his earlier work, though until now I had no idea he had been painting this Blue Dog

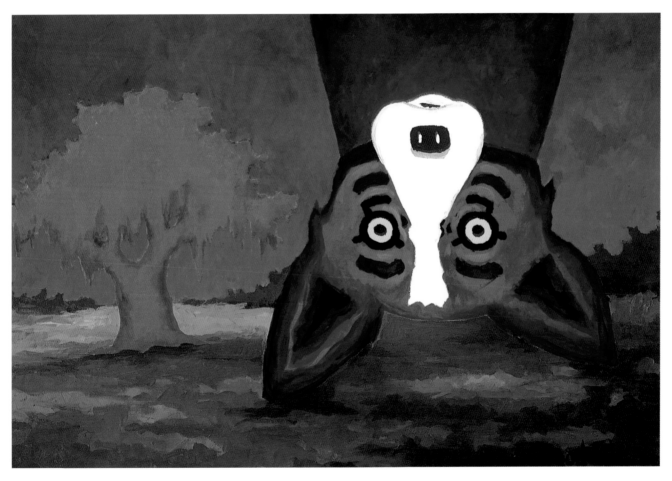

We Live in an Uncertain World
My long-time friends all showed concern for my uncertain
future as an artist. To me, the joy and happiness of my creativity
never hung out there as an unknown. It never suggested an
unsuccessful future. I was most happy being in the position
of doing what I loved.

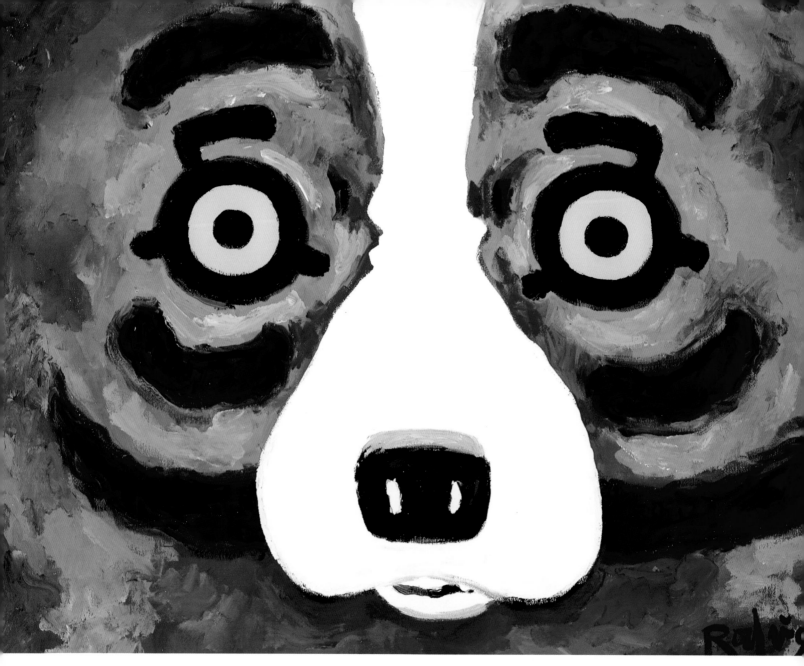

In Your Face

People think I dream of Blue Dogs, but I know I dream of happiness, love, and good times. I've never even had a nightmare. One recent night I dreamed I went shopping with Frank Sinatra for a new suit.

almost exclusively for the past year or so. I learned from my friend that the painting that had stopped me in my tracks when I walked into the gallery was called *Loup-Garou* and was based on the old, familiar Cajun werewolf legend.

Eventually we got around to talking about the matter at hand—finding me a job. My friend suggested a gallery down the street. I applied and was hired right away, but my experience there was short-lived (I quit after one day) and confirmed my worst suspicions about the art business: People will say absolutely anything to sell a painting. I didn't know how I could live with myself working in that environment, and I felt soured on the whole enterprise. But about a week later I got a call from my friend at the Rodrigue Gallery; he was offering me a job. It was such a small operation that I hadn't even considered asking when I first visited. I started on a Sunday afternoon, and I knew right away it was a perfect match. There's a lot to be said for a one-artist gallery; chances are that the people working there love the art.

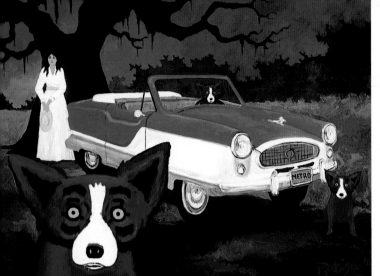

She Drove Me Crazy
In his epic poem "Evangeline," Henry Wadsworth Longfellow recounts the story of the Acadian people's exodus from Canada. His heroine Evangeline searches desperately for her lover Gabriel. Her journey takes her to south Louisiana, where she waits beneath the most beautiful oak tree—now known as "The Evangeline Oak."

The more time I spent around George's paintings, the more enthusiastically I talked about them with clients and visitors to the gallery. And not a breath of my enthusiasm was false. Yet I had still not met the creator of these paintings and prints; he was either back at home working in his studio in Lafayette, or he was on the road selling his work. The more I read about him, the more intimidated I became. Here was a man who had met U.S. presidents and movie stars and who, by all accounts, was still true to his small-town Louisiana roots. I read as much biographical information on George as I could get my hands on; I read up on everything that had been written about his painting style, about Cajun history, about the legends he incorporated into his work. After a couple of weeks I was telling visitors anecdotes about George's life and about his painting techniques as if I had grown up with the man.

So when, about a month after I had started working at the gallery, George Rodrigue strolled in carrying a stack of fresh paintings, I could barely look at him. And to my great

relief he barely glanced at me. I remember wearing an apple green linen dress that day; I just stood there blushing and glowing ("glow" is the polite term Southern ladies use for "sweat")—my dress looking more and more like a rotten apple. George seemed aloof, a fact I attributed to his celebrity status. I found out later, however, that I was merely the latest in a long series of twenty-something

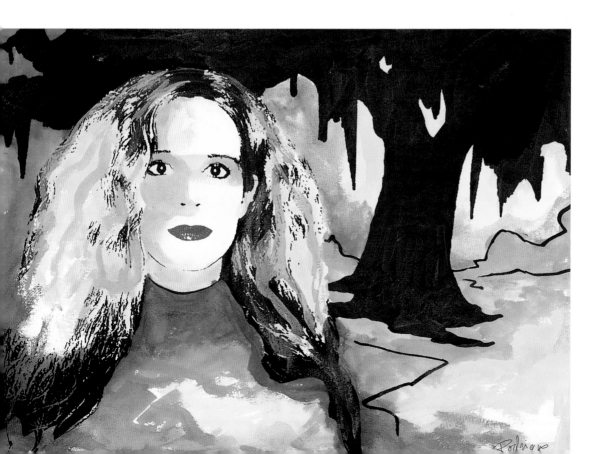

Louisiana Love
Jolie Blonde—my muse.

blondes that my friend (a man with a predilection for fair-haired women) had hired to work at the gallery. So naturally no one at the gallery—including George—had any reason to believe I'd last much longer than my predecessors. As it turned out I did last, and yet months went by before I could muster all but the most banal small talk with George. It wasn't until after I moved to Carmel, California, to work at George's gallery there that I started to be able to talk to the man like a normal human

Once that first veil of shyness dropped, however, a newfound confidence started to bloom. Something that happened on one particular evening comes to mind. Looking back, it was the smallest of gestures on my part, but after that night, I was never shy around George again. I had been invited to join George and his friends Tony and Lucille, clients from San Francisco, for dinner. At the end of the meal, Tony, a rotund, jovial, bald-headed man, perhaps emboldened by the wine, asked me for a goodnight kiss.

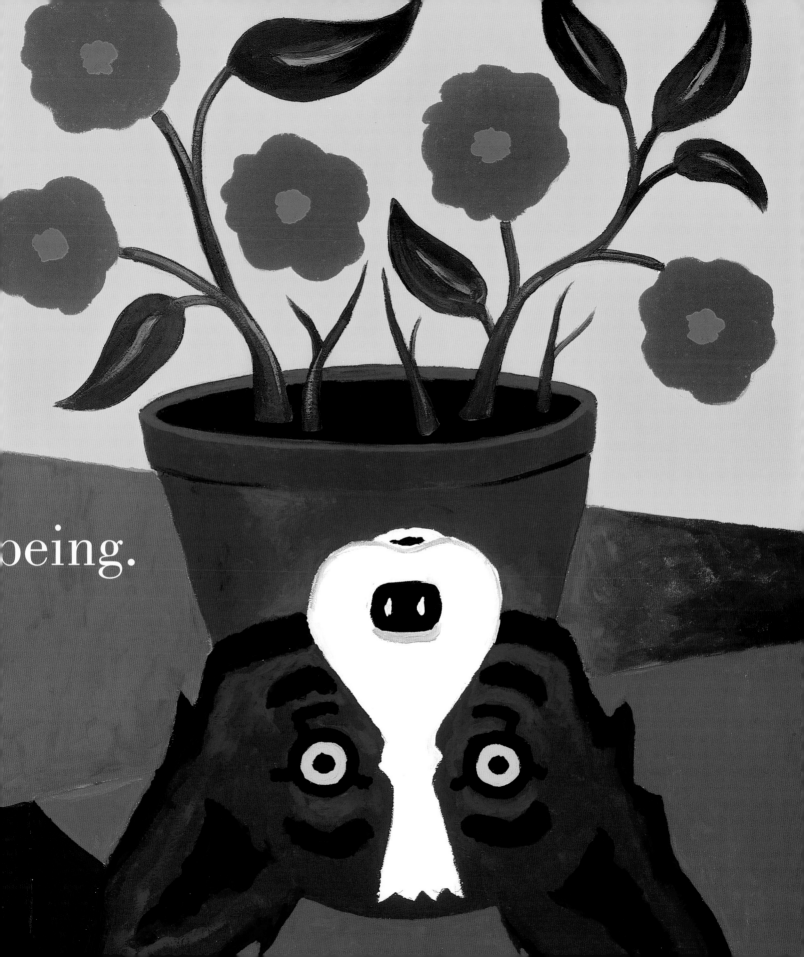

being.

Without hesitating (and without determining whether I had the blessing of Tony's wife), I leaned over and planted my lips on Tony's forehead. The moment George saw that bright red lip print on his friend's shiny pate, he burst out laughing (with his signature Snagglepuss-like "khee-hee-hee"). Maybe it was a sense of complicity between me and George, or maybe it was something else, but whether I knew it or not at the time, George and I crossed a threshold that night. . . .

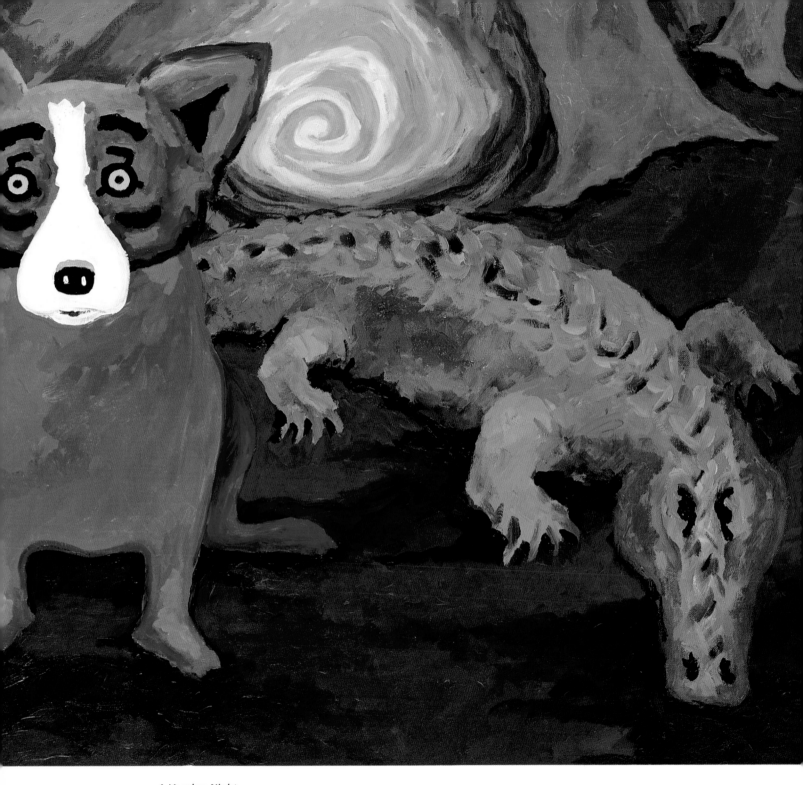

A Voodoo Night
Sometimes the things that sneak up on you are the best. Ten
years ago I already had my art, the bayous, and the love of
friends and family. Before I knew it, the Blue Dog and Wendy
changed my art and my life.

Chapter Two

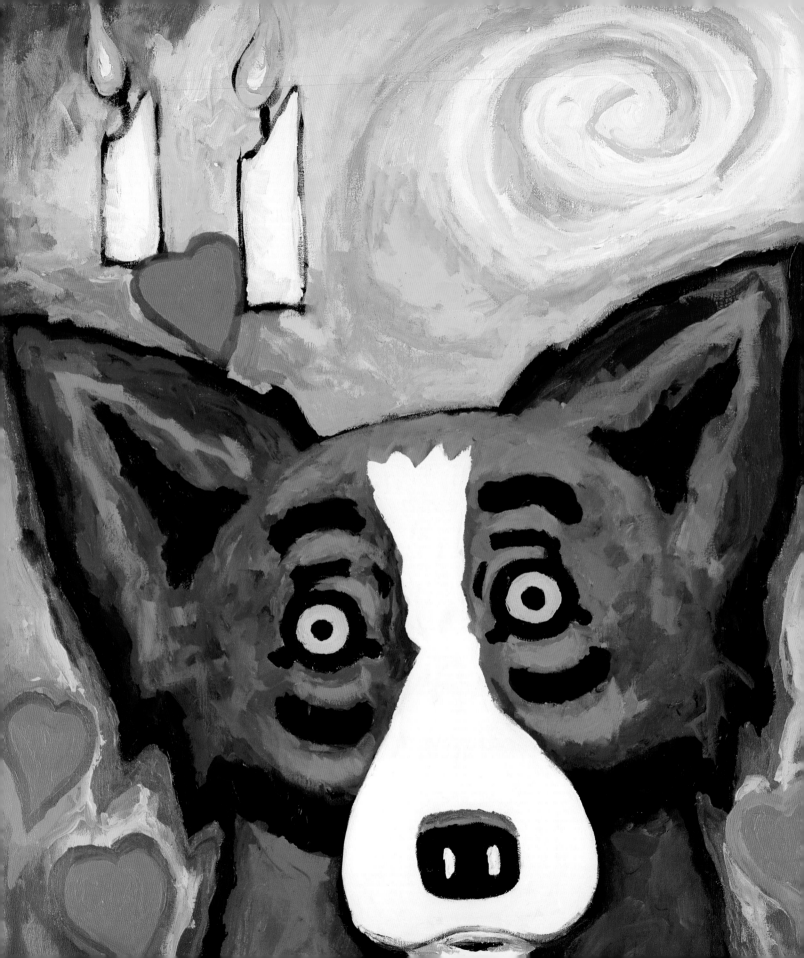

Passion is always exciting when you have no idea where you're going with it. When Elvis sang "a-hunk-a-hunk-a-burnin'-love," sparks flew for men and women everywhere. To capture that in a painting, I wanted the Blue Dog to look as bewildered and love struck as I was. I didn't paint fireworks, but the combination of the bright, swirling sun, hot candles, and glowing red hearts expresses my passion, as well as the strongest feelings of love I'd known in my life. I was a middle-aged man who thought he had experienced everything. Yet these were brand new feelings, and I could hardly wait to paint them.

Life is filled with the unexpected. I have always tried to encompass this concept in my paintings. I purposely put shapes and colors in places where the composition doesn't lead you to expect them. This feeling of excitement in art gives me and the viewer an extra charge. Here I've painted what people would say is the same blue dog, but to me this image has a bewildered and I've-just-been-struck look. Love has hit me squarely between the eyes, and I have no idea what's coming next.

–GR

BIG TROUBLE

*"A loveless world
is a dead world,
and always there comes
an hour when one is
weary of prisons,
of one's work, and
of devotion to duty,
and all one craves for
is a loved face,
the warmth and wonder
of a loving heart."*
–Albert Camus

AS I PUT IN MORE TIME AT THE RODRIGUE GALLERY IN CARMEL, VISITING AND HANGING OUT WITH GEORGE WHENEVER HE HAPPENED TO BE AROUND, I BEGAN TO ARRIVE AT A CURIOUS REALIZATION: George Rodrigue was not a normal human being. In my experience, normal human beings had mood swings, got depressed, succumbed to occasional moments of pettiness, got angry at people who didn't agree with them. Normal people also remembered phone numbers and street names, slept at night, went to their job during the day, and made a distinction between work and play. George did none of these things. I had never witnessed anyone—much less an artist—who suffered critics with such good-natured indifference, who so effortlessly laughed off both crude comments and gushing praise, who

so unquestioningly stoo

who seemed so unperturbed by the troubles of daily life, and who embraced his work with such childlike joy.

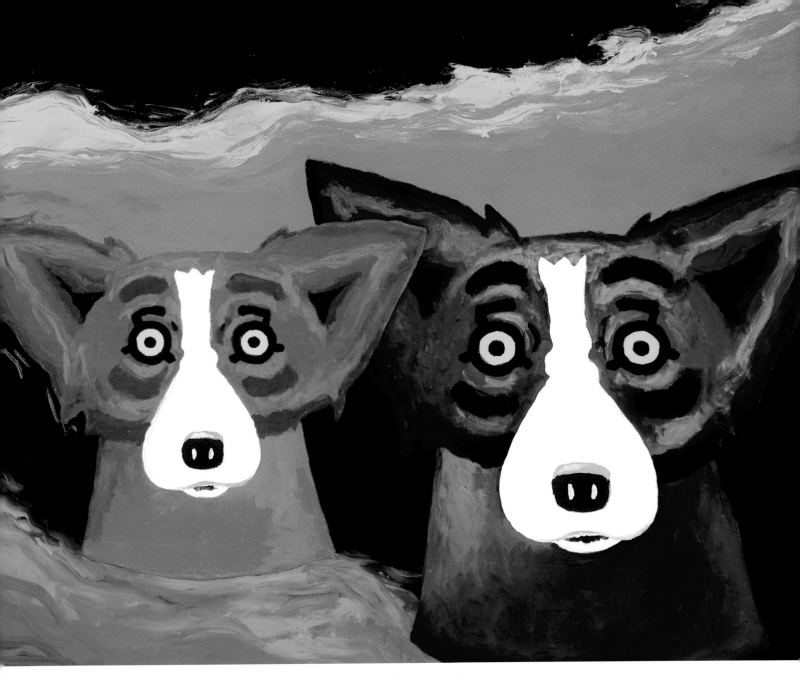

Islands in the Stream
Two wandering hearts find each other and become one.

by his friends,

Shades of Hollywood
At the airport, I never expected
two crazy women in a limo.

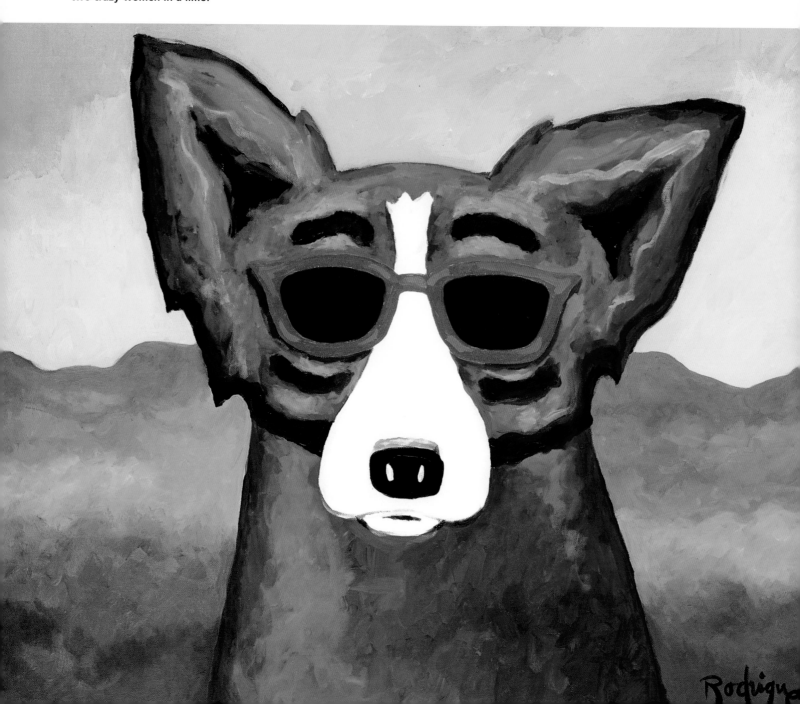

It was perhaps this understanding of George's character that had me and Sandra, my cohort at the Carmel gallery, a little worried during the summer of 1993. George wasn't painting much anymore, and the canvases he was bringing into the gallery seemed forced and uninspired. It just wasn't like George to be depressed, and Sandra and I were determined to do something about it. Sandra came up with a plan. George was due to arrive that evening at the airport in San Jose, an hour's drive away, for a week-long stay in Carmel. So Sandra and I, incurring our very first business expense outside of office supplies, hired a stretch limousine, bought some champagne, donned black sunglasses and alluring get-ups (Sandra convinced me to wear a black chiffon jumpsuit—way out of character for me), and headed for the airport. When George emerged from baggage claim, Sandra and I emerged from the sunroof, looking like a couple of Hollywood groupies.

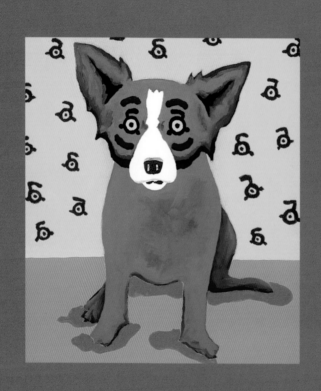

When you love someone, life before you knew that person becomes a distant, fuzzy memory that rarely surfaces unless someone asks you about it. Yet in the present that person becomes an inseparable part of every moment. You would never imagine a future without them.

This unusual reception had George khee-hee-heeing in no time, and we joked and laughed during the entire ride back to town.

We had booked George a room at the sprawling Tally Ho Inn, and by the time we got back to Carmel it was late and the front desk was closed. Since I had drunk less champagne than Sandra, I got the job of helping George find his room in the dark. When I turned to leave, something crazy happened, something I wouldn't have anticipated in my wildest imaginings: He tried to kiss me. George Rodrigue tried to kiss me. It took me a moment to react; I can still remember my exact words to him: "That's big trouble. BIG BIG trouble." When I got back into the limo with Sandra, I told her what had happened. "I'm not surprised," she responded nonchalantly, "motors were rollin' in here!" Whatever the heck that means. Nevertheless, I was resolved to put the whole event out of my mind and to forget about it completely—which is exactly what I did.

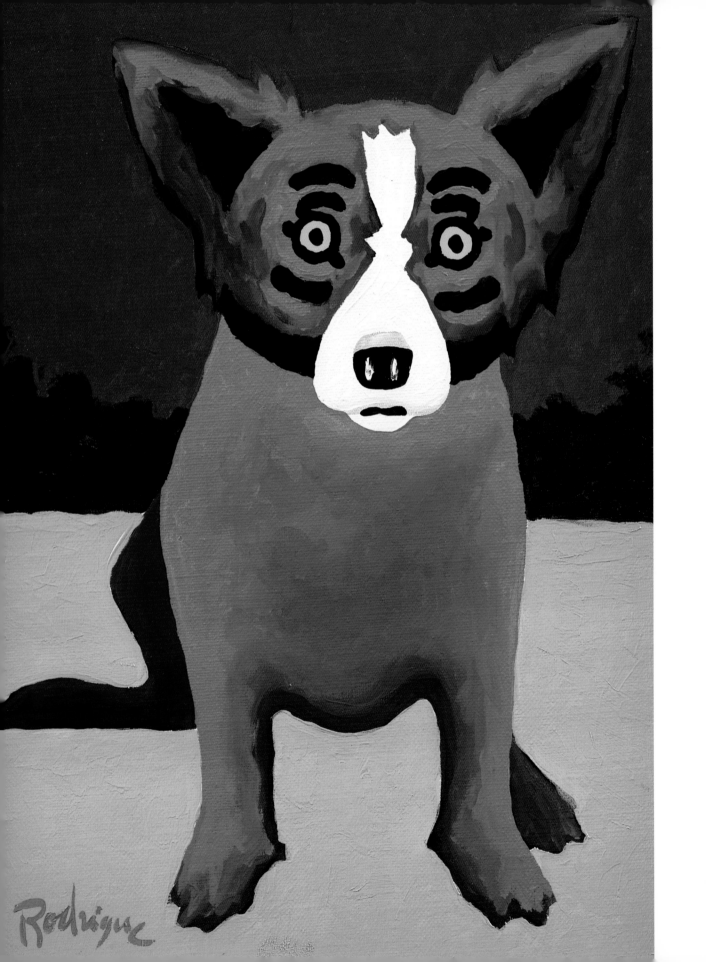

Hot Night at the Beach
The day of our first date was a
bitterly cold and windy one.
Things warmed up faster than
either of us expected.

Our cheer-up plan was not limited to one evening and a limo. Sandra crammed George's weeklong visit with sightseeing trips, conducted alternately by each of us, while the other one covered the gallery. She was first; I think she took him to Big Sur. I was to take him up to Sand-Dollar Beach the day after. It was mid-afternoon by the time we reached the beach, and a relentless wind was howling off the ocean. I remember my hair blowing straight out and my ears aching as we strolled along the boardwalk. I suggested that, rather than freeze to death, we cut our losses and head back to the gallery. Then I remembered that there was a bar next door to this Mexican-food place called The Whole Enchilada in nearby Moss Landing: Dollar bills hanging from the ceiling (seven thousand of them, according to the bartender), Harley Davidsons at the front door, Hell's Angels drinking at the bar, year-round Christmas decorations, and a blues band that could turn bar brawlers into dancing partners.

Bad Thoughts
Wendy thinks we fell in love in one night at The Whole Enchilada.
Truth is, I had hot thoughts before that.

As so often happens in life, a most fateful and life-changing experience began with the simplest of propositions. In this case, it all started with the words, "Wanna get a

There I was, ignoring what I thought was my better judgment, asking George Rodrigue out for a beer. Ironically, it was one invitation George could not accept in full; the man didn't drink. But we headed to The Whole Enchilada anyway, and for the next few hours, we sipped cokes, talked, ate, danced among the bikers and mill workers, talked some more, and completely lost track of time. Sandra's plan seemed to be working: George was in high spirits, as happy as I could ever remember seeing him. It turned out our normally happy artist just needed to talk.

As the evening wore on, George just let the words flow, and I just sat there and listened. While I was haunted by the feeling that I very much didn't belong there, alone in a bar with George, at the same time I was exhilarated. By

beer?"

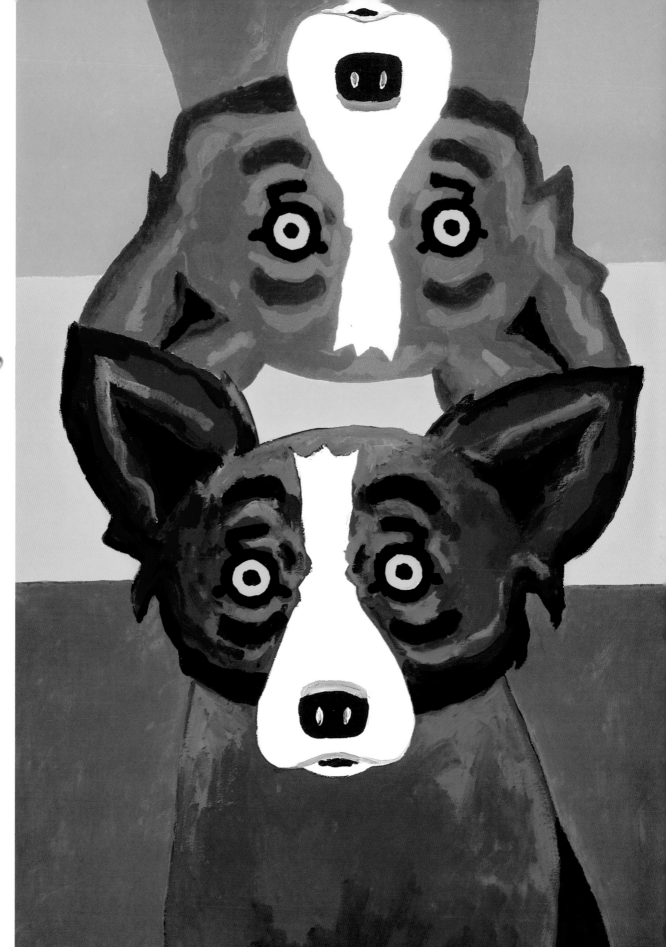

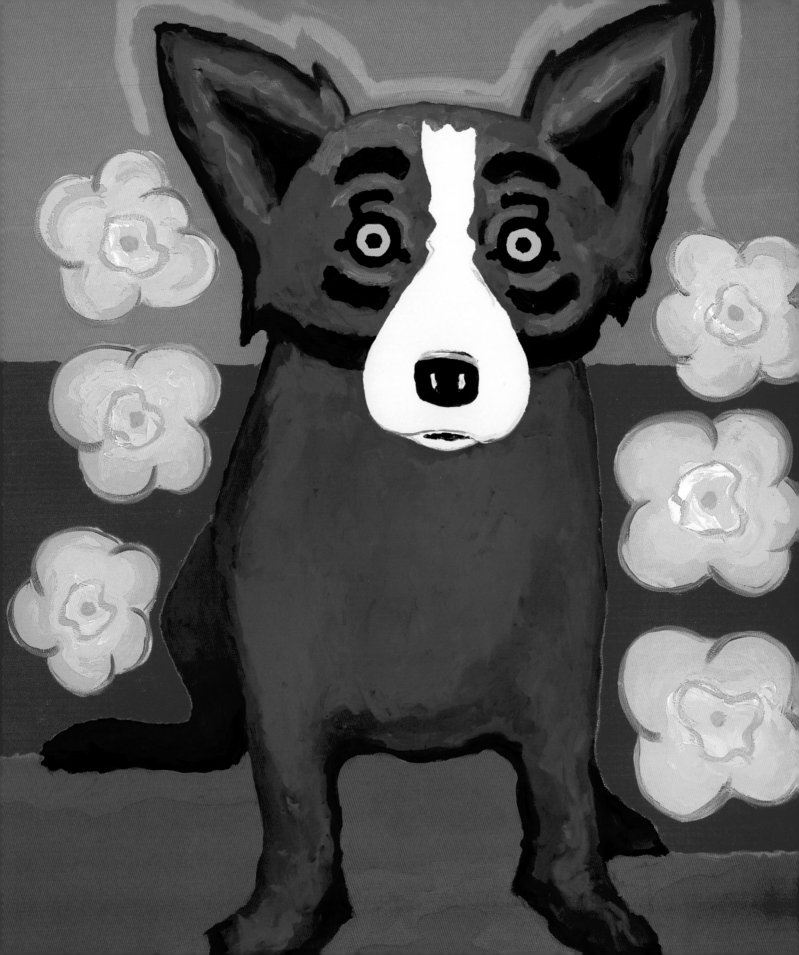

The Day Love Bloomed
**After ten hours of conversation, six tamales, and two hours
of dancing, love bloomed.**

asking George out for a beer, I knew I had just done the
bravest and most daring thing I'd ever done in my life. It
all seemed surreal. We both knew something else was
going on besides a friendly chat. By the time the sun went
down and the band got up on stage for their first set,
George and I were in love. . . .

At the time I lived in a small, ramshackle cottage known
euphemistically as a "Carmel Charmer." It was one of
many like it nestled into the hills of the sleepy seaside
community. People whisper after dark in Carmel, and
there are no sidewalks or streetlights. I always used to
half-joke that if I tripped on the uneven pavement and fell
flat on my back one dark night, I would not dismay.
The stars shine brighter in a world without streetlights,
and as I lay there I could ponder my existence, my
thoughts uncluttered by noise and light, save for that of
the stars. So as George and I stood in the darkness at my
front door, after ten hours of ceaseless conversation at The
Whole Enchilada and an awkwardly silent ride home,

I forced back a sharp ache, certain I could never have a relationship with this man, and announced in a voice that seemed to shatter the still air:

"This is the deal"—I was saying it as much to myself as to him: If George wanted to talk, I would listen. If he needed some companionship, I would be there. But every minute I spent with him would be about the moment. There would be no discussion, no dreaming, about the future. I would allow myself to believe only that I was bringing some joy to George's life, and no more. I would not let myself believe he actually wanted me—only that he had chosen to share part of himself with me for a short while. And most important, we would talk about this with no one.

Once the night was over, I reminded myself of the cold, hard facts. George was my boss. I could lose my job. He was exactly twice my age. He had a lifetime of experiences that I hadn't even dreamed of. And we were both

from the South, where ideas about love and marriage aren't exactly flexible. The odds were just too long, and the risks too great. What I didn't know at the time was that I had failed to factor into this seemingly hopeless equation two crucial facts: First, George Rodrigue is not a normal human being, and second, I am more of a risk taker than I gave myself credit for. . . .

Red Hot Kisses
When I kissed Wendy, the Blue Dog's blues were just a distant memory.

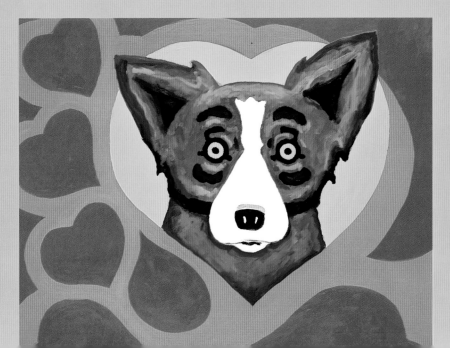

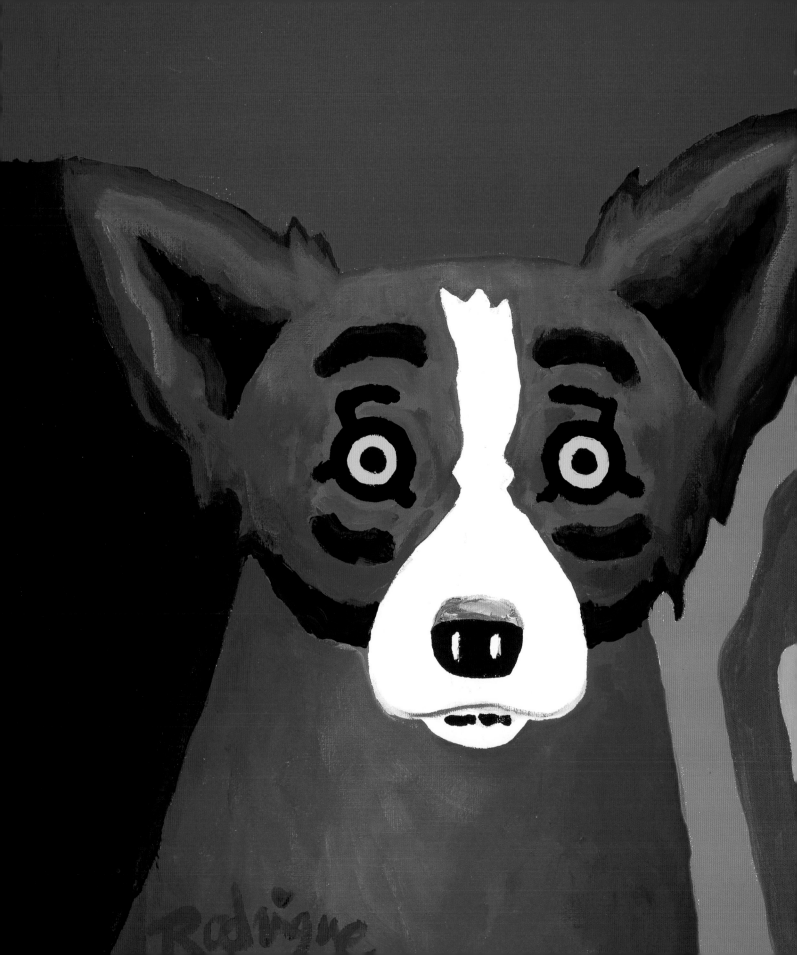

Blue

Dog

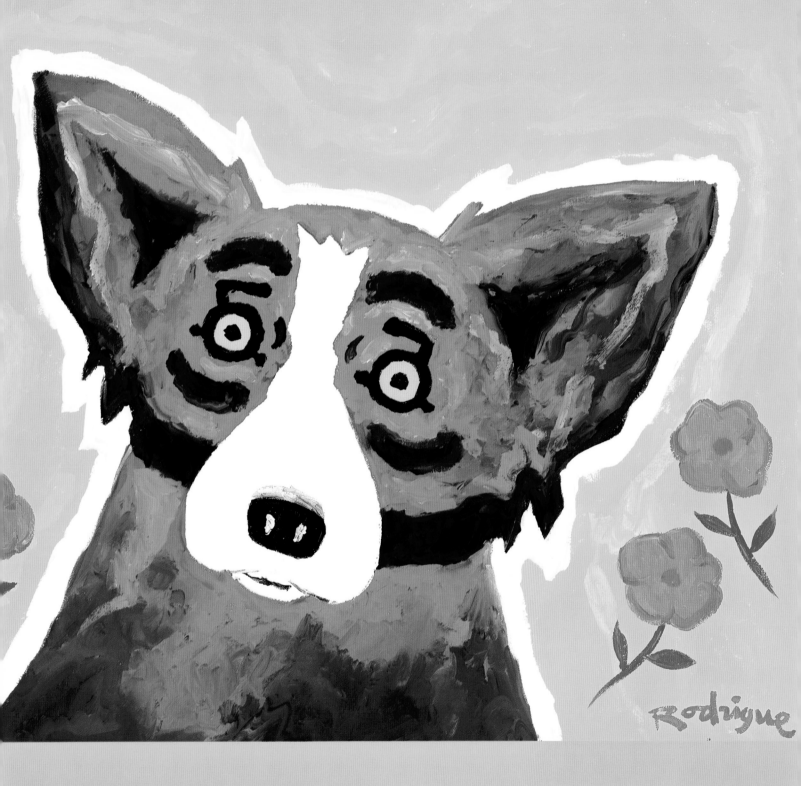

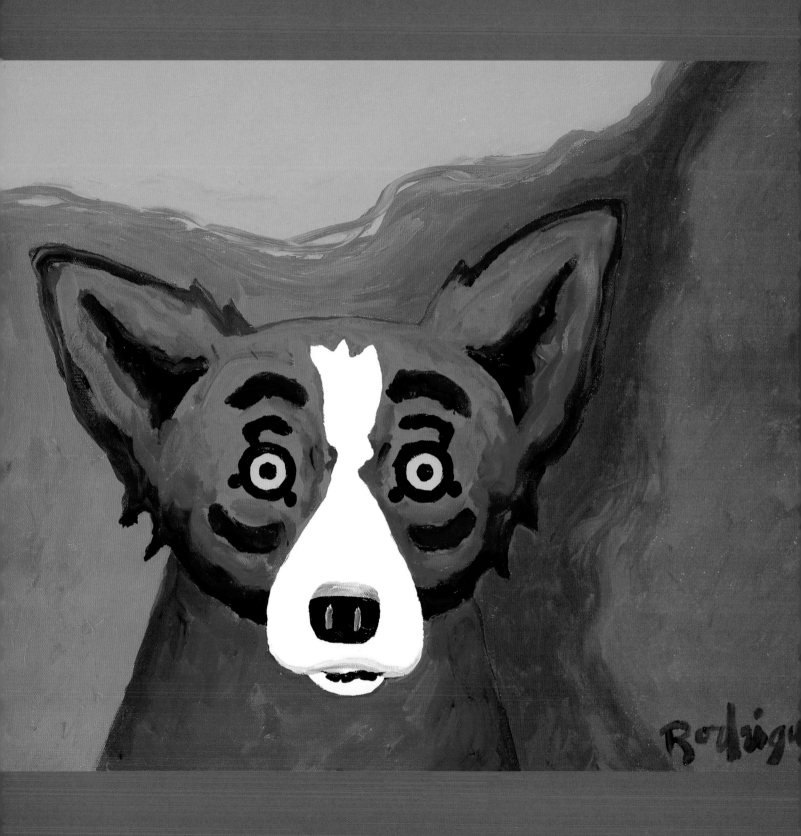

Love

The first passion
in my life was art
I controlled it,
had fun with it
and loved it
beyond all things

when a person became part of my love, my life and my art changed. I have no boundaries and my freedom of expression is limitless.

Chapter Three

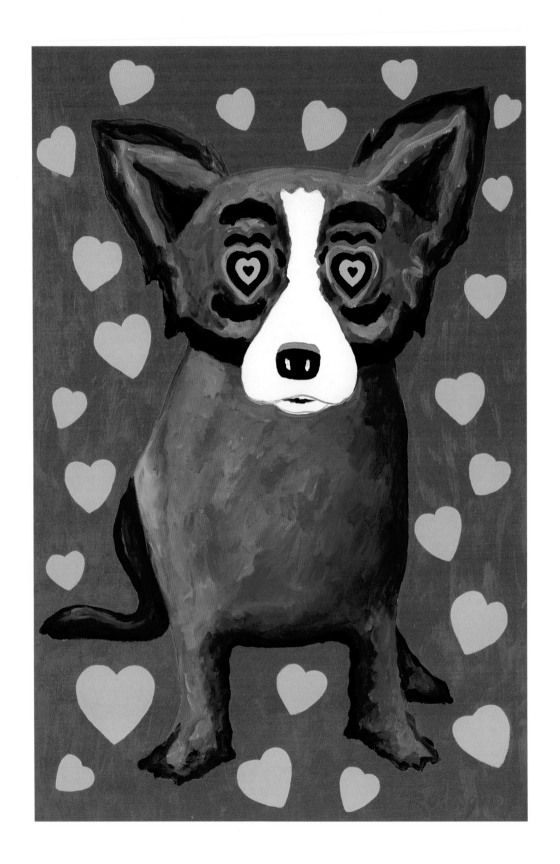

Although we kept our love a secret, people who were close to me sensed that I had found something different in my life. Looking back, I must have had love in my eyes. It's a funny thing about love: Deep love is private and you think no one sees it. But really, everyone sees there's something different. I thought my deception was successful because she was in California and I was in Louisiana. But when I traveled back to Louisiana, I must have worn my heart on my sleeve.

One autumn I had returned from California and the leaves were falling. I remember looking up at the oak trees and thinking that these were not leaves, but hearts, falling all around me. Love truly changes your perspective on everything. I dove into the leaves, looked up at the sky, and wondered, "How can this be? Does love affect everyone this way?" I ran to my studio and tried to create something from this crazy feeling. When ideas come out of nowhere and are very spontaneous, they are sometimes the best. Love is a constant catalyst for inspiration.

–GR

LOOKS LIKE LOVE CAME OVER ME

I GREW UP IN THE SOUTH, AND I AM NO STRANGER TO OLD-FASHIONED TRADITIONS. SOME PEOPLE WOULD SAY THAT GEORGE RODRIGUE GREW UP IN THE SOUTH TOO, BUT THEY WOULD BE ONLY HALF RIGHT. George Rodrigue grew up in Cajun country. He was born and raised near the banks of the Bayou Teche in New Iberia, Louisiana, where your family's name and your daddy's occupation forever define who you are; where you're an old maid at twenty-two; where girls learn the family recipes and boys learn the family trade; where everyone goes to Catholic school; where friends stay friends and enemies stay enemies to the grave and usually beyond. The basic ideas about religion and family that George's French-speaking forebears brought to the Louisiana swamps when they fled south from Canada more than two hundred years ago have remained largely unchanged.

And yet you would be hard-pressed to find anyone as unencumbered by tradition, as open to new ideas, as downright unconventional as George Rodrigue. For a man

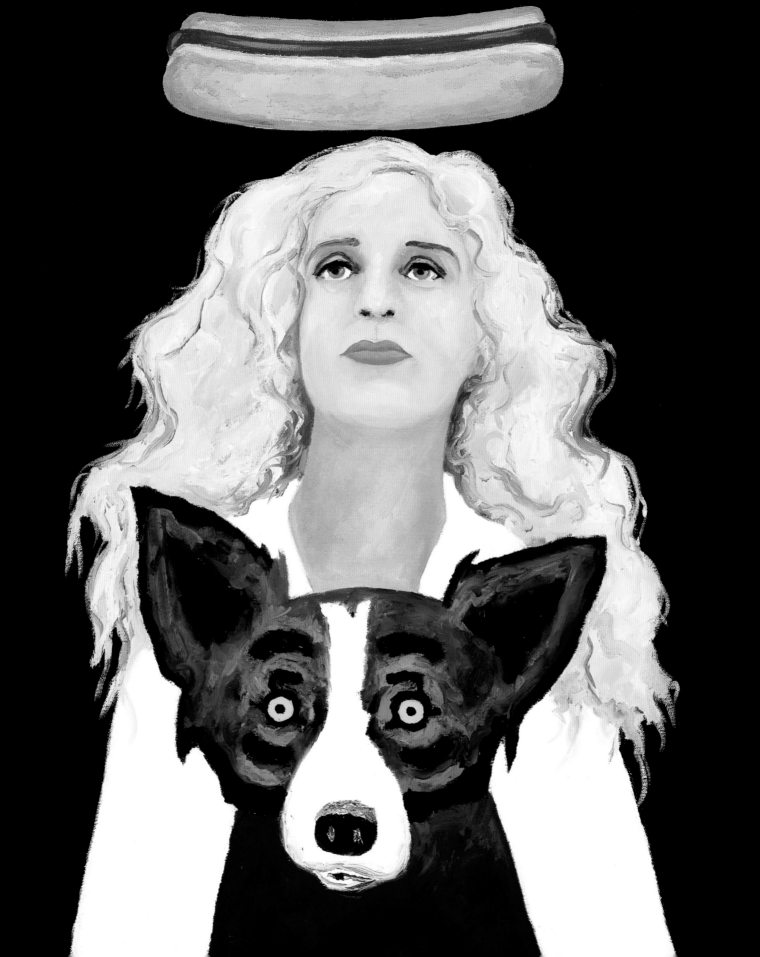

steeped in the somber imagery and spooky legends of Acadiana, George lives life exuberantly and without fear or regrets. And, as I would soon discover after that unforgettable night at The Whole Enchilada, he is

hopelessly romantic....

Before I could even register what was happening, my tentative but fateful "Wanna get a beer" snowballed into a six-month whirlwind of secret rendezvous and long-distance romance. It started with an invitation to spend the weekend with George at a place called the Mission Ranch, on a breathtaking stretch of coast near the Carmel Mission. That first weekend, I was practically paralyzed with nerves, self-consciousness (especially about my looks), and even guilt, but George erased all that. He filled the nervous air with an easy stream of words and ideas; he took my picture; he talked about art; he mentioned guilelessly that I reminded him of the figures in the work of a Parisian painter he knew. He told me I was

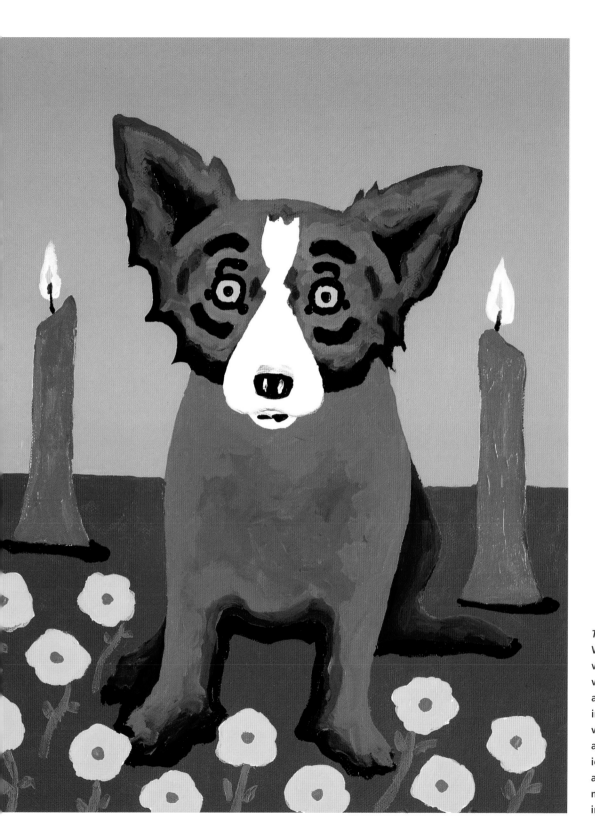

Two Hearts in Love
When we first started dating, we both felt independent. We were honest with each other about what we were getting into. In a way, I thought it would stay that way. Instead, an "us" formed, which embodies all of the qualities we held as individuals. In our case, ultimately, two hearts became one in the minds of both people.

beautiful. There is a powerful and tempting romance behind the idea that one might be an artist's muse. And I'm sure that's part of the reason I gave in to my emotions that weekend and found the courage to just let things happen.

After that first weekend George would often fly secretly to Monterey and we would meet at Big Sur. When we were apart, we talked on the phone every night. When I opened the gallery in the morning, I'd find love faxes waiting for me—sketches of me or of the Blue Dog with hearts and kisses. I'd find Fedex packages covered in drawings and filled with presents—hand-painted bottles of red hots, collages of photographs and sketches, or even a beaded dress with a note, "Meet me at Mard

One day I'd be working in the gallery in Carmel, wondering when I'd next get to see George, and the next day I'd be on a plane to Paris to meet him.

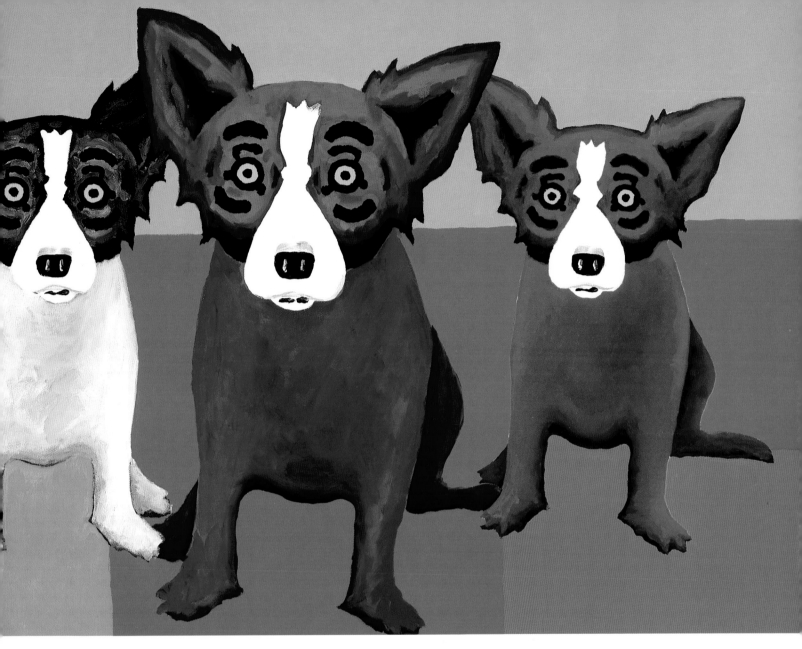

Gras!"

Blue Waters

I've been fortunate to know the love of many friends. Personalities change, time together lessens or increases. The older I get, the more people enter my life, and the less time I have for each friend individually. But that's the great thing about old friends. Those memories stay with you forever. The love never lessens, and we can pick up after months apart, as though we just saw each other yesterday.

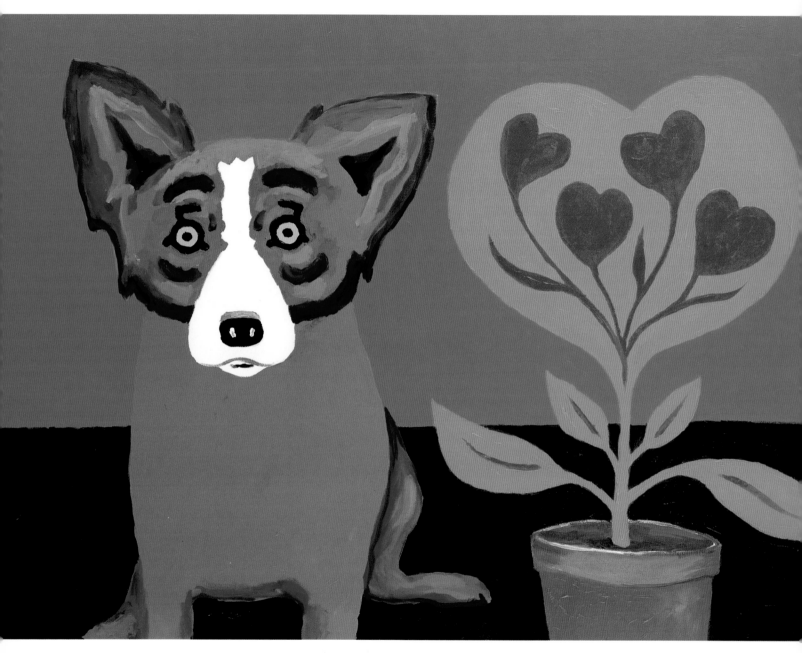

Love Me, Watch Me Grow
Every time I visited Carmel, Wendy gave me a tour of the new blooms and sprouts in her garden. I never painted flowers before Wendy showed them to me.

I also developed a passion for gardening around this time, which helped distract me from the loneliness when George was away. The love and tenderness I felt for George I would pour into my garden when I couldn't be with him. I'd be outside at daybreak, tending to flowers and pulling weeds, and after work I'd run home with seedlings and dying plants I hoped to nurse back to health. I took joy in every leaf and petal. And when George returned, we'd tour the garden, noting every change since we'd last seen each other. In time flowers and plants—never a major element in his paintings before—began to enliven his canvases.

When we were together, the romance only intensified. At restaurants he would draw my portrait on the tablecloth; I would frame each of them—food stains and all—and hang them in my room. George's gestures of love could be lavish and impetuous. One evening I happened to mention that I played piano. The next day, while I was at work, he and five other guys took apart the balcony on my little

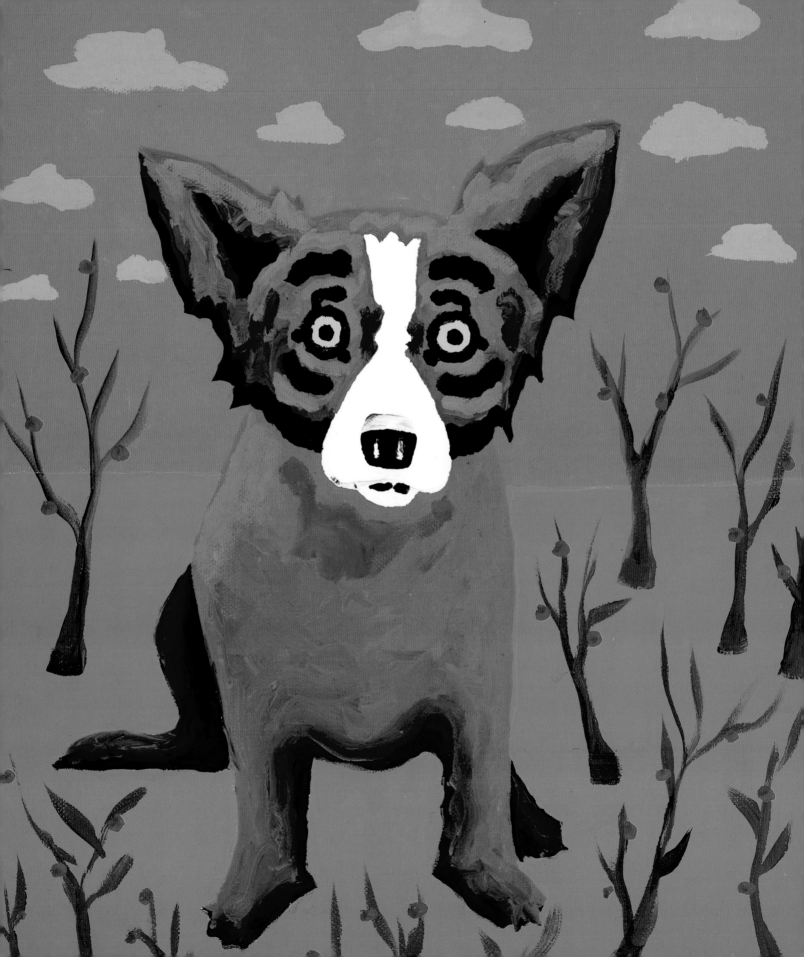

Popcorn on a Bud
Love makes you do crazy things. I used to search song lyrics
for ideas for painting titles. Now they come naturally—and
they often make no sense whatsoever.

rental house and hoisted an upright piano into the living room so it would be waiting for me when I got home, as if it had always been there. When George was in Carmel, our every thought and action was about being together. I wanted to cook for him, but he said that the time I spent in the kitchen was time we could be spending walking on the beach, eating in a cozy restaurant, or gazing at the embers in my fireplace.

All the time this was going on, I struggled over and over again with the big question: Where was this going? I tried as hard as I could to keep my emotions in check, to live in the moment just like I promised myself I would, but I found myself hoping against hope that maybe, just maybe, George and I could make this work. We shared so many passions—among them a love of music, art, and travel—and our age difference seemed only to enrich our relationship. We were able to teach each other about our respective generations, and we were able to laugh at the different ways we viewed the world. This, and our

frequent cross-country separation, just brought us closer together. As for George, if he ever had any doubts, he certainly didn't let on.

After six months of keeping our relationship under wraps, we decided to come out of hiding. And just like the Blue Dog paintings did, the news inspired an endless variety of reactions and unsolicited advice on the part of friends, family, and colleagues. George laughed it all off just as easily as he did criticism of his paintings. Indeed, George's art was more exciting than ever around this time. He had definitively left behind his somber Cajun landscapes in favor of bright, surreal Blue Dog compositions set in ever wilder, more imaginative environments. Blue Dog paintings filled the gallery, stacked to the ceiling, and passersby stuck their heads inside and asked,

"What's with that

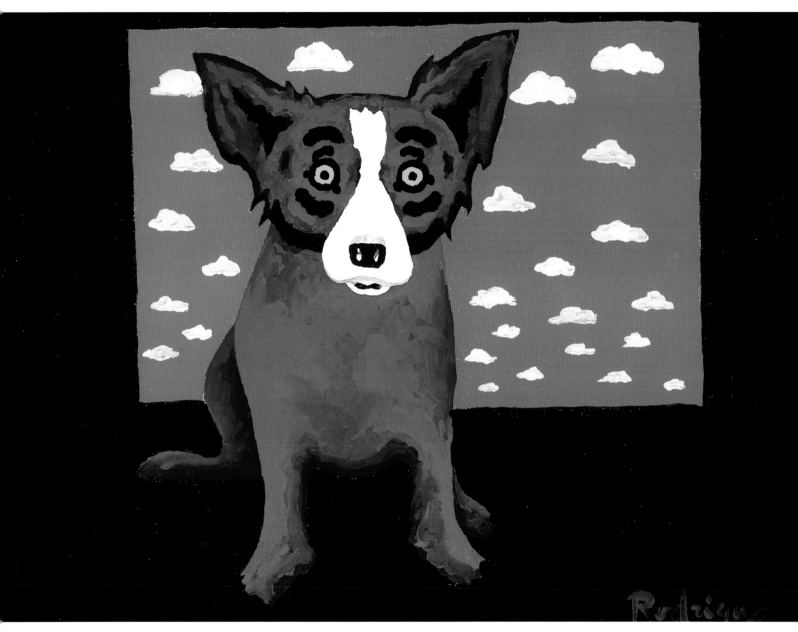

blue dog?"

A Window of Happiness
When Wendy and I were dating, if I was not in California,
I was trying to get there. Its landscape and its mood open a
window of happiness for me. This new found joy was soon
reflected in my paintings.

I'd eavesdrop on their conversations about the paintings, and sometimes, late at night, I would walk by the gallery and try to imagine seeing a Blue Dog again for the first time.

The more time I spent with the paintings, the more blurred became the distinction for me between them and the man himself. Not surprisingly, I found myself instinctively leaping to George's defense every time someone uttered a word of criticism about his work—and the more publicity the Blue Dog paintings received, the stronger people's opinions got. Invariably, George would dismiss them with a khee-hee-hee and just get back to doing what he loved—painting. But I would become indignant; I'd stay up nights brooding over a single comment overheard that day. By the same token, I'd float on air for days after reading a rave review or hearing a heartfelt compliment from a happy customer. One thing was certain: I never got tired of talking to clients and visitors about George or about the Blue Dog paintings; I was the best PR person an artist could ever hope for. But for me, I knew that it all

pointed back to one inalienable truth: I was falling ever more deeply in love with George. And while I knew we could sail along happily like this for months or even years, one day we would have to reach a turning point. . . .

Chapter Four

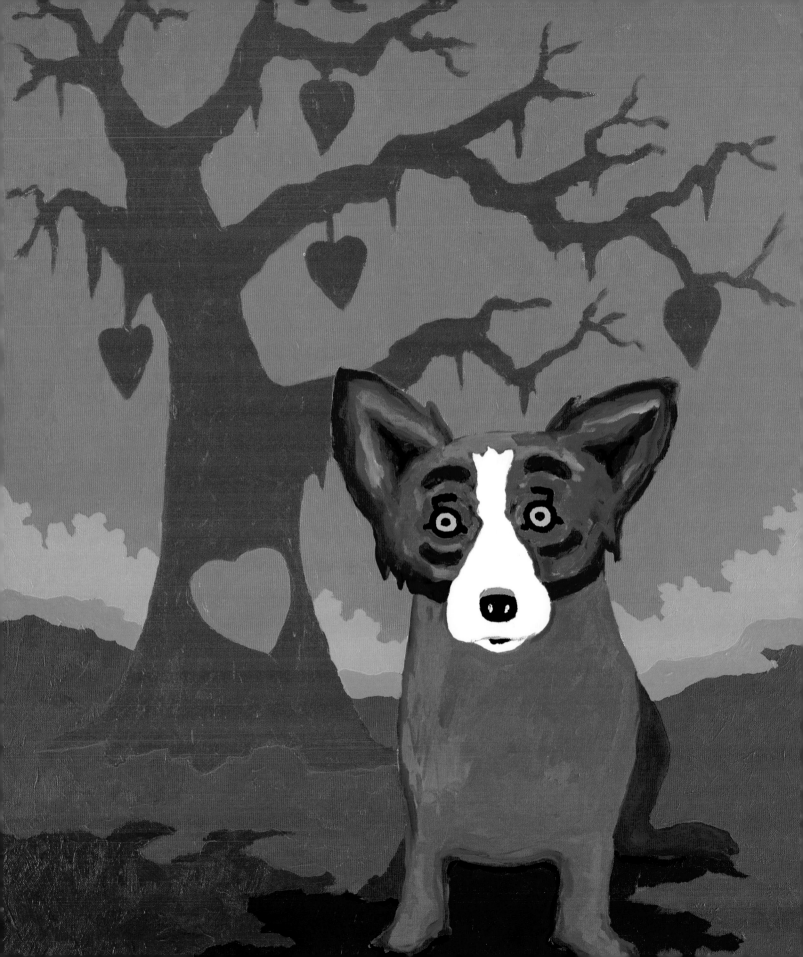

People said my Louisiana oak trees, which were dark and full of moss, were brooding, dull, and uninspired. Those same people want the old oak trees back, now that the trees are full of life—with bright colors, dramatic shapes and, in this case, candy kisses. For years I've known that I have to paint to please myself first. My paintings reflect my mood, and if I changed them to please others, the act of painting itself would cease to be a joy—and would just become work.

Here I sit underneath my Louisiana symbol and look at my life with a new passion for living. Love entered my life at just the right moment. I share my thoughts with someone who sees her surroundings in the same way as I do. For the first time, someone other than the subjects of my paintings has joined me on my journey.

One March afternoon we were married underneath an oak tree on an island in New Iberia. I wanted to celebrate the moment with a painting that combines my typical oak tree and the candy trees of Christmas. Here you can pluck a heart from a branch anytime you want, and recommit to each other.

—GR

JUST IN TIME

THE PROBLEM WITH FALLING IN LOVE WITH A MAN LIKE GEORGE RODRIGUE WAS THAT I COULD NEVER REALLY TELL WHETHER OR NOT I WAS ACTUALLY REACHING THAT TURNING POINT IN OUR relationship—for the simple reason that everything felt like a turning point. Whenever George and I were together, I felt like I was crossing a new threshold and gaining fresh perspectives on life. I was learning so much so fast. Whether I was watching him paint, visiting a museum with him, or taking a cross-country road trip, spending time with George was turning all my notions about art and beauty and love upside down.

And I think I was able to help George develop new ideas as well. Inspiration came to him at the oddest times and in the most varied forms. He would leap out of the shower to write down a book idea; he would sketch out a design for a painting on an air-sickness bag on the plane; he'd wake me up at three in the morning to tell me about a new setting for a Blue Dog painting that came to him in a dream. And George's creative impulses weren't limited to

86

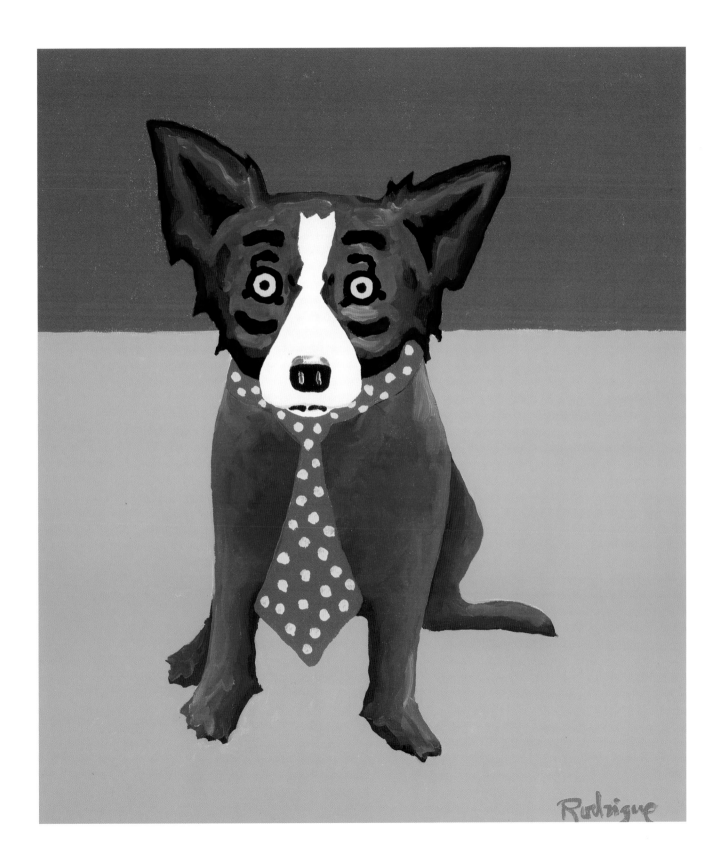

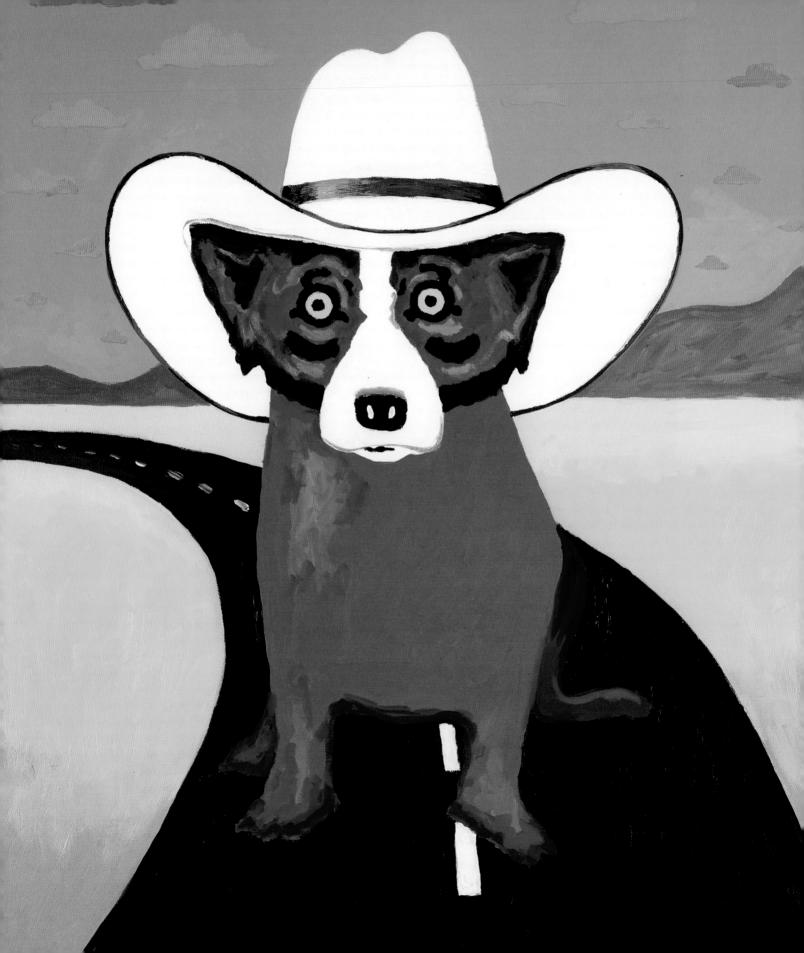

For many years, after two or three weeks of painting, I would
rejuvenate myself and my ideas by traveling across the country
to show the new work to friends and collectors. Today I do
the same thing, but without paintings in tow. The best kind of
vacation for us is a road trip without a set schedule. I've taken
Wendy to all the places I went on my own for years. She shows
me things I never noticed before.

painting: He sketched car designs, wrote screenplays—
all sorts of things. All the time we were dating, I never
once saw George take advice from anyone about what
to paint or how to paint it, and yet I soon found myself
being asked for my opinion. He frequently described
his art as a journey, and he told me that I was now his
companion on that odyssey.

For four years we shared this exciting journey together,
traveling across the country to see each other and running
up phone bills, and despite the distance and George's
soaring popularity, our love seemed to be growing stronger
all the time. And yet when I brought up the subject of mar-
riage—something I did ever so delicately only once a year
or so—George would just grin, laugh his signature laugh,
and deftly change the subject. So one autumn day, just to
preserve my sanity and perhaps because it was just my
nature, I politely but resolutely issued an ultimatum. It
wasn't an outrageous one; I merely told George, "If you
don't marry me by the time I'm forty, there's a chance

I'll leave you." A pause, a warm smile, and—as if I could have expected anything else—another khee-hee-hee. Satisfied that I had done all I could do, I left it at that.

I guess I was a fool to think that George, who hadn't heeded a word of advice from anyone his entire adult life, might ever respond to an ultimatum. Sure enough, it turned out that George had his own plan all along. A few months later, at a Christmas party with family and friends, he produced a ring and announced that we were getting married. I was dumbstruck, and I was sure there had been some misunderstanding. I was twenty-nine years old; my ultimatum wouldn't come due for another decade. When I asked him about it, he said matter-of-factly, "I didn't pay any heed to your ultimatum. I was just waiting until you were thirty."

And so on March 1, 1997, two weeks before my thirtieth birthday, George Rodrigue and I were married beneath a hundred-year-old oak tree on Jefferson Island in

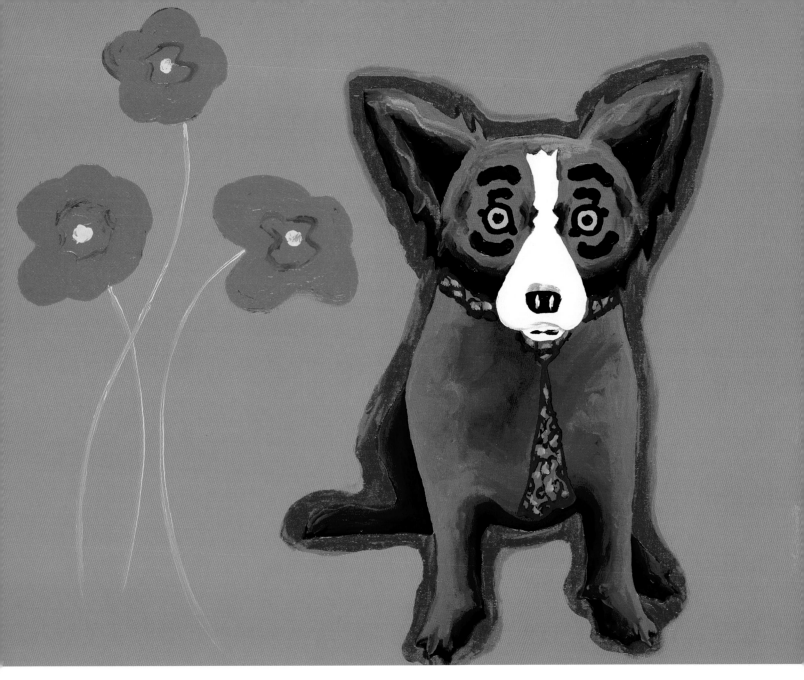

Three Roses for a Love
One rose for you, one rose for me, and one rose for us.

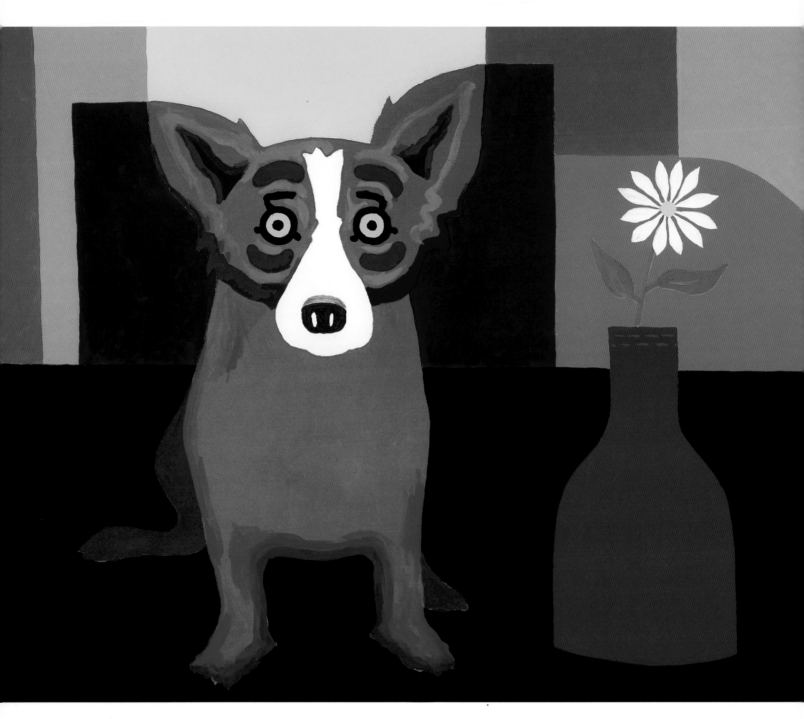

Daisy May

I've always been a night owl—painting until three or four in the
morning and then sleeping until ten. In the morning my wife is
Daisy May: She's bright, cheery and full of life by six A.M. Since
we moved to California, I've started getting up earlier!

Louisiana. In front of hundreds of our relatives and dearest friends, amidst *three thousand tulips* shipped specially from Holland by George as a surprise for me, we took our vows as storm clouds loomed overhead. The music I had selected for this part of the ceremony was a recording of the Puccini aria "O Mio Babbino Caro," sung by Kiri Te Kanawa (I had decided on this piece for my wedding way back when I was eighteen). Just as the first strains flowed from the speakers, the clouds broke. I stood there in the sunshine and watched this man I had shared my life with for four years declare his love for me in front of everyone we knew. As we were pronounced husband and wife, Dean Martin sang "Just in time. I found you just in time. . . ."

And this is really where the great love story of my life begins. This is where we embarked on a beautiful and awesome new journey, where we took the first steps in the never-ending endeavor of building and nurturing a life together. We were no longer two hearts separated by

circumstance and distance, and the ache of uncertainty
was replaced by a sense of common destiny, and by the
knowledge that no matter what happened from here on
out, all that counted was that we were together. After four
years of long-distance love, George and I are resolved to
never be apart. We work together, travel together, sleep,
eat, laugh, and cry together. Perhaps it is just a byproduct
of having had to keep our love a secret and of then having
to keep it alive across the span of a continent, but every
moment I've spent with George after we got married
seems as precious as our first hours together.

In the months and years that followed, our lives have
gotten busier and busier as George's Blue Dog art earns
him ever more attention—and as I got more involved in
the work of running the Blue Dog business. We remain a
family operation, and we struggle to accommodate the
flood of requests for interviews and appearances while
still trying to stay in touch with longtime friends at our
home in Louisiana. Privacy has become a premium

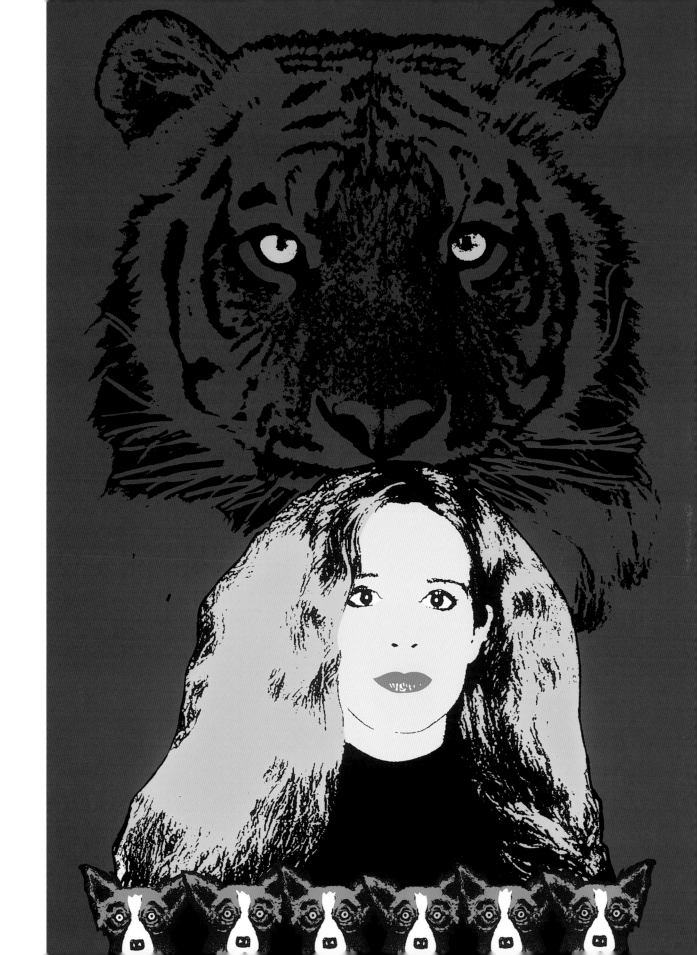

infinitely more precious than money or publicity. All the while, George continues to paint, now doing his most creative work in the relative quiet of Carmel, where we spend more and more time. Whenever we have a few weeks off, we get in our truck and head out West, where George finds new inspiration for his painting.

Every once in a while I accompany George to his childhood home in New Iberia and watch as he casually rummages through the attic, cluttered with the countless photos, drawings, and sketches left untouched since his childhood. George seems as at home in the attic of this tiny brick house as he does at mobbed book signings and gallery events. This is what never

View from the Top
From my current vantage point—knowing freedom and success as an artist, seeing my children become kind-hearted, responsible young men, and sharing a life of love and friendship with the person who knows me best—the oak trees of my past seem like small stepping stones.

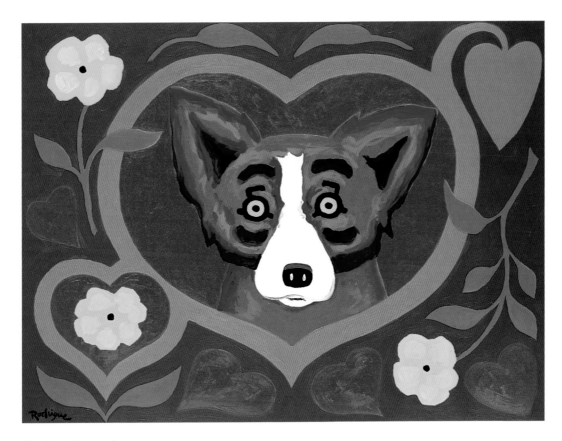

Our Love Blooms Forever
**Remember the movie *The Princess Bride*? Not even death
can stop true love.**

ceases to amaze me: No matter how busy and frantic our
lives get, we still are able to live in the moment—just like
we had during the first intoxicating months of dating. We
find more immediate joy in the way an Aspen leaf flickers
in the sun than we do in contemplating any sort of
material success.

George told me not long ago that he believed he had gone
through all the uncertainty and obstacles of his early life
and career just so that he would be ready for "us" when it

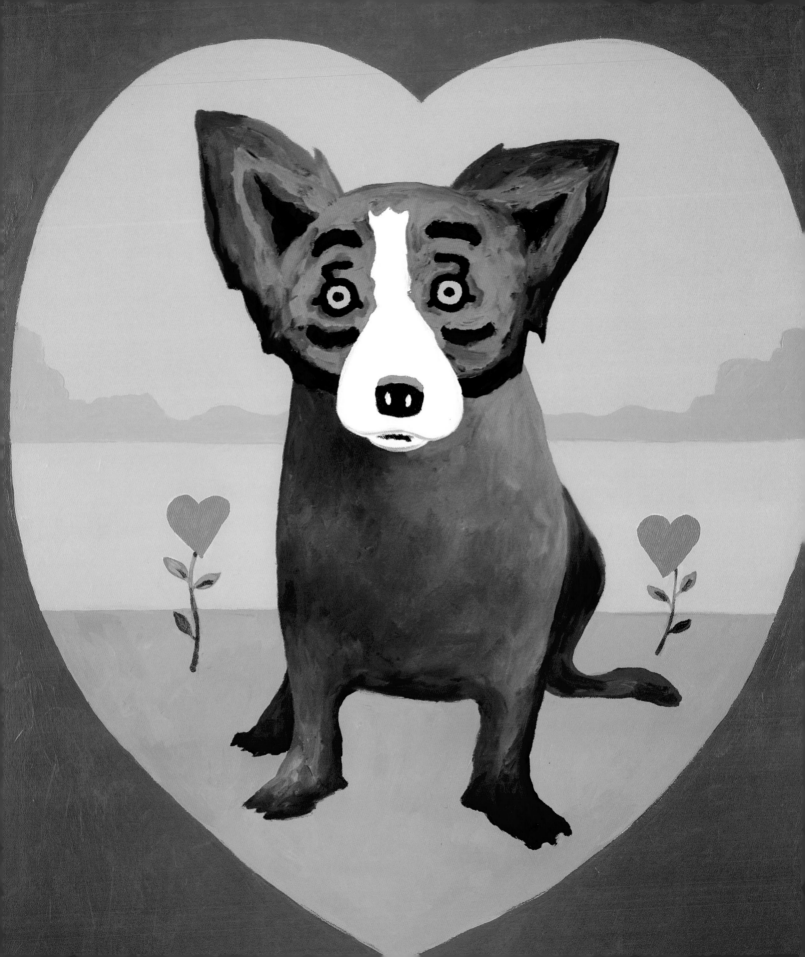

My World Is Full of Love
**Above all else, I am grateful for the love in my life. That's how
I define success.**

happened. We both believe that the past is the past—that it should be valued as a vessel of memory and knowledge, but that it should not be a burden. George is a man who lives very much in the vivid present, and yet he grew up in a culture that places great value on tradition and nostalgia. And so I suppose I shouldn't have been surprised when, a few years after we got married, George showed up at the house with a very special Blue Dog painting. It was *Loup-Garou*, the very same canvas that had bewitched me when I first set foot in the Rodrigue Gallery on Royal Street almost a decade before. I still don't know how he got it. The painting had been sold years ago. But there it was, right in front of my eyes once again, as brilliant and haunting as ever. Today, *Loup-Garou* hangs in our house, **a living symbol** of our life together—a beautiful ode to my love for my Blue Dog Man.

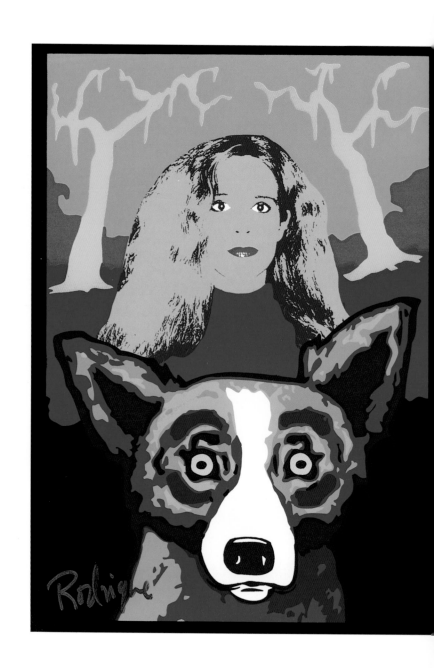

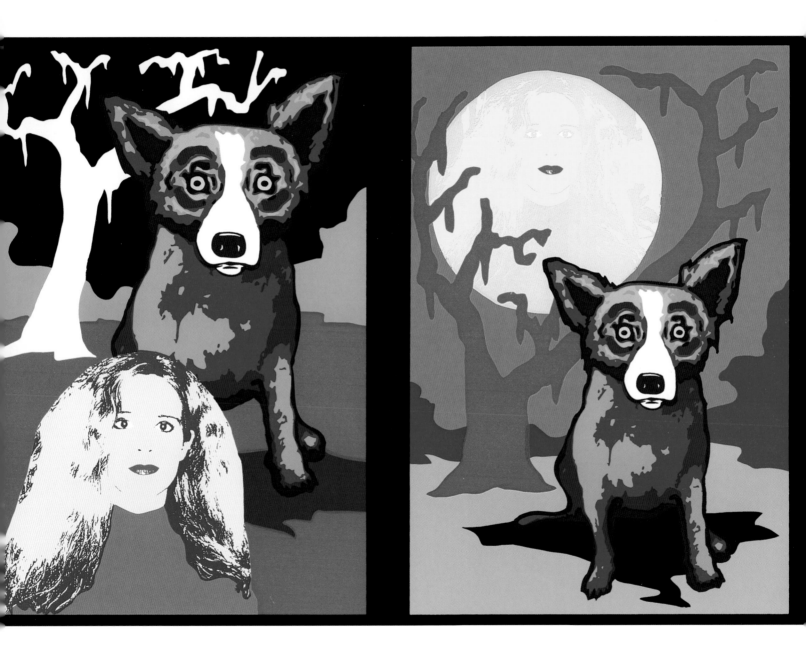

Epilogue

George is
my Don Quixote,
the brave, honest man
with a heart
generous and true.
And I'm
his Dulcinea,
the girl no one expected
him to love.

–WR

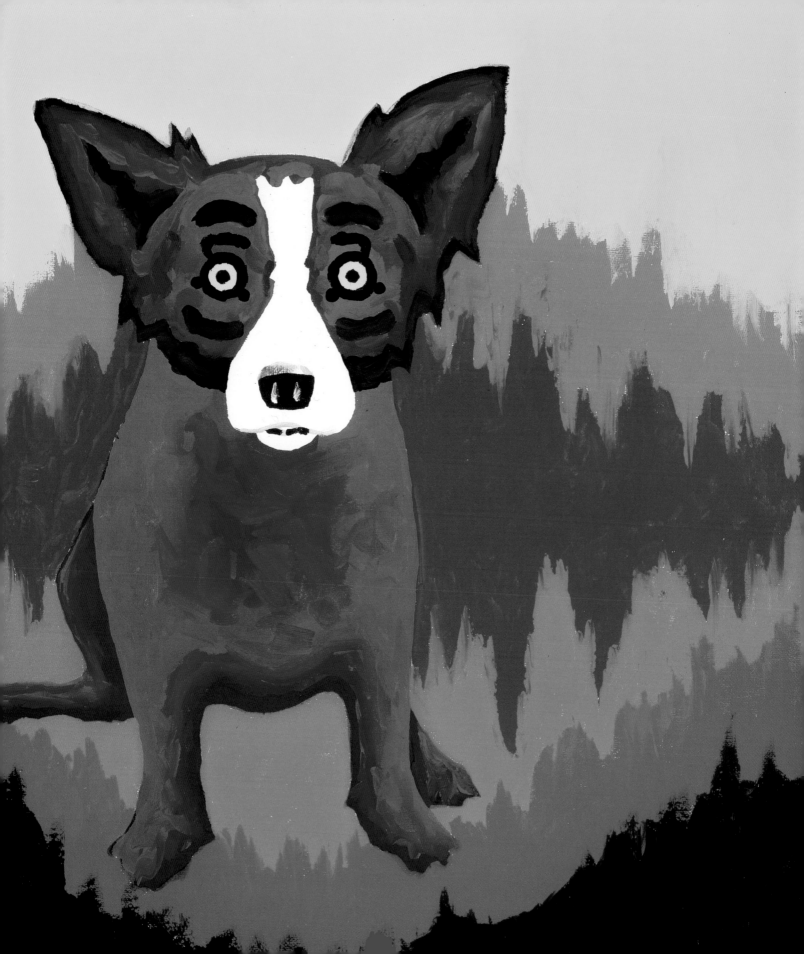

My first secret love was painting. My second secret love was Wendy. There's no reason to keep secrets anymore.

–GR

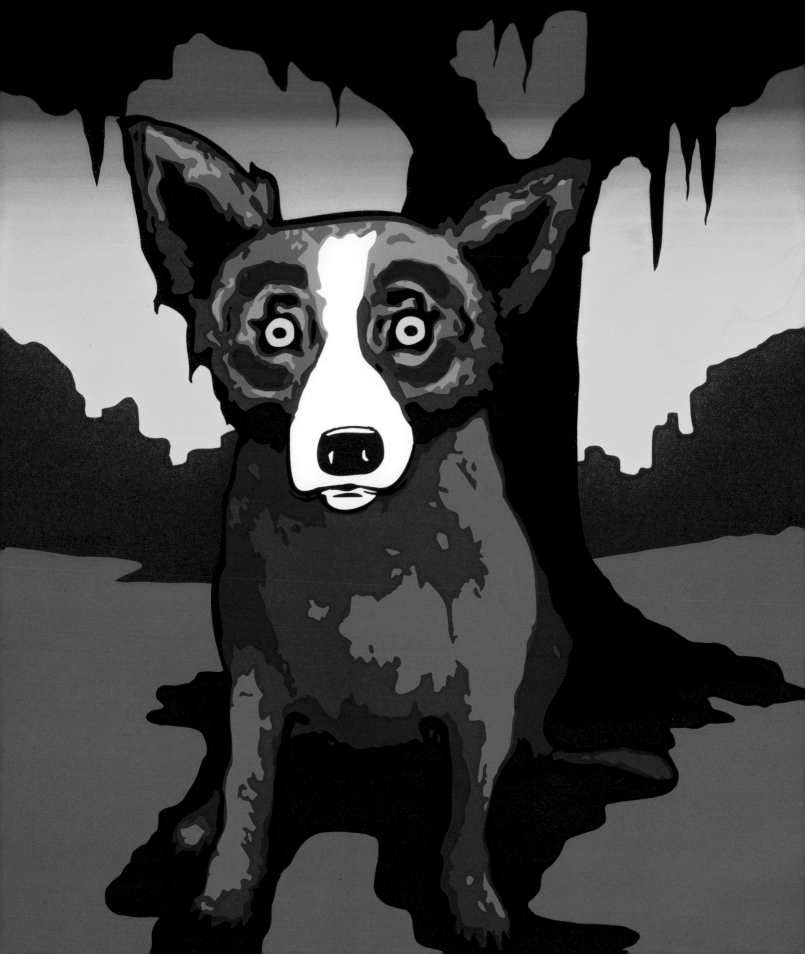

Published in 2001 by
Stewart, Tabori & Chang
A Company of La Martinière Groupe
115 West 18th Street
New York, NY 10011

Library of Congress
Cataloging-in-Publication Data
Rodrigue, George.
Blue dog love / by George and Wendy Rodrigue
p. cm.
ISBN 1-58479-088-1
1. Rodrigue, George. 2. Painters–Louisiana–Biography.
3. Tiffany (Dog) in art. 4. Love in art. I. Rodrigue,
Wendy. II. Title.

ND237.R69 A2 2001
759.13-dc21

2001032828

The text of this book was composed in Bodoni Book
and captions were composed in Frutiger.

Printed and bound in Toppan Printing Co., (H.K.) Ltd.
10 9 8 7 6 5 4 3 2 1
First Printing

Design by Alexander Isley Inc.
Project Editor: Sandy Gilbert
Production: Kim Tyner

LITERARY SOURCES
(The numbers preceding entries refer to page numbers.
Every effort has been made to trace copyright holders
of material in this book.)

26 Kahlil Gibran, *The Prophet* (New York: Alfred
A. Knopf, Inc.), p. 14. Copyright © 1923 by Kahlil
Gibran. Renewal copyright © 1951 Administrator
C.T.A. of Kahlil Gibran Estate and Mary G. Gibran.

42 Albert Camus, *The Plague*, trans. by Stuart Gilbert
(New York: The Modern Library, a division of Random
House, 1948 edition), p. 237.

68 E. M. Forster, *A Room with a View* (New York:
Bantam Books, a division of Bantam Doubleday
Dell Publishing Group, Inc., 1988, first published
in 1908), p. 197.

86 Emily Dickinson, "Proof" from *Favorite Poems
of Emily Dickinson* (New York: Avenel Books, 1978,
originally published in 1890 as *Poems*), p. 55. Special
material copyright © by Crown Publishers, Inc.

Works of Art
(All works of art featured are acrylic on linen unless otherwise noted.)

Heartache Blues, front cover
2000, 16 x 20 inches

Paul Revere, 3 (detail)
2000, 36 x 48 inches

Valentino's Revenge, 6 (top)
2000, 40 x 30 inches

*In My Heart You'll
Live Forever*, 6 (middle)
1998, 16 x 20 inches

Be My Valentine, 6-7
2001, 20 x 26 inches, silkscreen
(edition of 150)

*Calling Capt. Kirk
from the Red Planet*, 6 (bottom)
2000, 20 x 24 inches

I Married Someone Like Me, 7 (top)
2000, 15 x 22 inches, silkscreen
(edition of 140)

The Only One, 7 (middle)
2000, 16 x 22 inches

Orange, Texas, 7 (bottom)
2000, 24 x 30 inches

I'm Looking for Someone Like Me, 8
2001, 30 x 20 inches, silkscreen
(edition of 90)

Wendy and Me, 12
1997, 24 x 36 inches

A Bouquet of Memories, 14 (detail)
2000, 36 x 24 inches

Peep-eye in the Poppies, 16 (detail)
2000, 36 x 24 inches

Love Beacon, 19
2001, 30 x 24 inches

It's a Wild, Wild Life, 20-21
2000, 72 x 30 inches

Love's Sneakin' Up On Me, 24
2001, 30 x 24 inches

The Original Loup-Garou, 27 (detail)
1990, 72 x 48 inches

We Live in an Uncertain World, 29
2000, 24 x 36 inches

In Your Face, 30
2000, 30 x 40 inches

She Drove Me Crazy, 32
1997, 30 x 40 inches

Louisiana Love, 33
2001, 23 x 30 inches, watercolor

Inner Joy, 35
2000, 40 x 30 inches

A Voodoo Night, 36-37 (detail)
2001, 24 x 36 inches

Light My Fire Tonight, 40 (detail)
2001, 48 x 36 inches

Islands in the Stream, 43
2000, 36 x 48 inches

Shades of Hollywood, 44
2001, 24 x 30 inches

I See You Forever, 46
2000, 20 x 16 inches

Hot Night at the Beach, 48
1999, 12 x 9 inches

Bad Thoughts, 51
2000, 36 x 24 inches

The Day Love Bloomed, 52
60 x 48 inches, 2000

Red Hot Kisses, 55
2001, 24 x 30 inches

Light Shades, 56-57
2000, 16 x 20 inches

Happiness, 58-59
2000, 30 x 40 inches

*Underneath a
Warm Blanket of Love*, 60
2000, 16 x 20 inches

Looks Like Love Came Over Me, 66
2001, 36 x 24 inches

Hot Dog Halo, 69
1994, 30 x 24 inches

Two Hearts in Love, 71
2000, 14 x 11 inches

Blue Waters, 72-73
2000, 24 x 30 inches

Love Me, Watch Me Grow, 74
2001, 30 x 36 inches

Popcorn on a Bud, 76
2000, 14 x 11 inches

A Window of Happiness, 79
2000, 12 x 16 inches

A Secret Love, 81
2001, 30 x 24 inches

The Love Tree, 84
2001, 30 x 24 inches

Going Out to a Party, 87
2000, 24 x 20 inches

On The Road Again, 88
2001, 30 x 24 inches

Three Roses for a Love, 91
1999, 16 x 20 inches

Daisy May, 92
2000, 36 x 48 inches

Tiger Paws, 95
1997, 34 x 21 inches, silkscreen
(edition of 70)

View from the Top, 96
2000, 36 x 24 inches

Our Love Blooms Forever, 97
2001, 40 x 30 inches

My World Is Full of Love, 98
2001, 30 x 24 inches

Night Love, 100-1
1997, 16 x 35 inches, silkscreen
(edition of 50)

Electricity of Love, 105
2000, 18 x 24 inches

Dawn of a New Love, 107
2001, 25 x 20 inches, silkscreen
(edition of 90)

Lipstick Blues, 112
1999, 24 x 18 inches

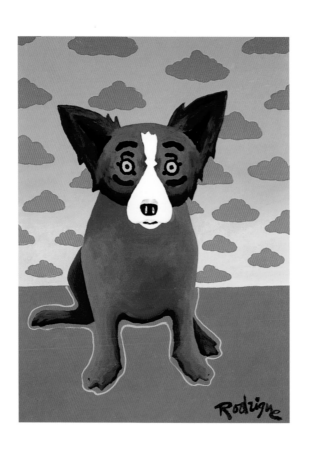